The Drawing Center
October 2 – December 20, 2015
Main Gallery

Richard Pousette-Dart
1930s

Curated by
Brett Littman

DRAWING PAPERS 122

Essays by Charles H. Duncan *and* Lowery Stokes Sims

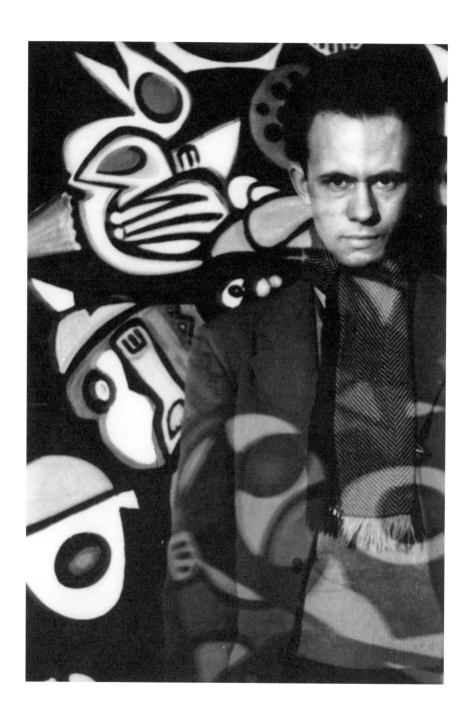

FIG. 1
Richard Pousette-Dart, *Self-portrait*, c. 1939

Foreword

A year and a half ago, Joanna Pousette-Dart invited Olga Valle Tetkowski, The Drawing Center's Exhibition Manager, and me to look at some works that her father, Richard Pousette-Dart (1916–1992), made during the 1930s: drawings, notebooks, and brasses (hand-held sculptures). We were not particularly familiar with these pieces; there have only been a handful of exhibitions that have focused on this period of Pousette-Dart's career, and these works have generally not been highlighted or published in great quantities in larger survey exhibitions and catalogues. Both Olga and I were stunned and entranced by what we saw. I don't think that either of us had ever in our careers witnessed work made by someone between the ages of fifteen and twenty-five that had such presence and quality. As well, we were intrigued by Pousette-Dart's early figurative studies, which are clearly building blocks for his extraordinary pre-abstract paintings from 1938–39 like *Head, African Head, River Metamorphosis, Primordial Moment*, and *Head of Woman*.

Our interest piqued, we began a long research process in collaboration with the Pousette-Dart Estate to review several hundred works on paper, brasses, and notebooks with the goal of putting together a comprehensive exhibition and catalogue of the artist's work from the 1930s that would enhance scholarship on Pousette-Dart and establish these works as seminal and important to an understanding of the artist's oeuvre. Best known as a founding member of the New York School of painting, Pousette-Dart initially pursued a career as a sculptor. The son of Nathaniel Pousette, a painter, art director, educator, and art writer, and Flora Louise Dart, a poet and musician,

Pousette-Dart was raised in an environment surrounded by music, poetry, and the visual arts, and began drawing and painting by the age of eight. Introduced to African, Oceanic, and Native American art by his father, Pousette-Dart made frequent visits to the Museum of Natural History as a young man. In 1938, he forged a close friendship with the artist and theorist John Graham, whose writings were closely aligned with his own interests in spiritual concerns and so-called primitive art. Throughout the 1930s, Pousette-Dart was most influenced by the work of Henri Gaudier-Brzeska, a French-born, British-based artist associated with the Vorticist movement, whose abstract sculptures, drawings, and forms in brass greatly informed the orientation of the young American artist.

Richard Pousette-Dart 1930s is the first in-depth museum consideration of his drawings from the 1930s, a period when the artist pursued directly-carved sculpture, yet also painted, experimented with photography, and created numerous works on paper. These early drawings explore Pousette-Dart's concerns about sculpture and working three-dimensionally. Many reference the figure through full-frontal or profile views as they consider space, orientation, and volume. Additionally, numerous studies allude to dance, animals, masks and human heads, and many examples offer an accumulation of abstract and geometric forms, particularly for his brasses—small sculptures meant to be "held in the hand." The exhibition features approximately 100 works from the 1930's including drawings, notebooks, and brasses.

I am incredibly indebted to the Estate of Richard Pousette-Dart, especially to Evelyn, Joanna, and Chris Pousette-Dart, and John Bellidori, Collection Manager, who have generously allowed The Drawing Center the opportunity to engage with Richard's work. In addition, I would like to recognize Charles Duncan, the Executive Director of the Richard Pousette-Dart Foundation, who has been an indispensable guide through the material. I am also very grateful to Douglas Baxter from the Pace Gallery for his commitment to making the exhibition a reality. Charles Duncan and Lowery Stokes Sims also should be commended for their essays in this catalogue, which provide invaluable new perspectives on Pousette-Dart's formative early years as an artist in the 1930s.

I want to particularly thank Olga Valle Tetkowski, our Exhibition Manager, whose input and assistance has been absolutely essential in putting this exhibition together. She has been with me every step of the way during its conceptualization, planning, and installation, and for that I am very grateful and appreciative. In addition, I want to thank the following staff members at The Drawing Center: Molly Gross, Communications Director; Dan Gillespie, Operations Manager; Alice Stryker, Development Manager; Margaret Sundell, Executive Editor; Joanna Ahlberg, Managing Editor; and the graphic design studio AHL&CO for their help in realizing this important exhibition and catalogue.

Finally, I am grateful to The Drawing Center's Board of Trustees, The Estate of Richard Pousette-Dart, and Pace Gallery who have supported this exhibition and its accompanying publication.

—Brett Littman
Executive Director, The Drawing Center

Rock, Paper, Brass:
Richard Pousette-Dart in the 1930s

Charles H. Duncan

* I would like to thank Lowery Stokes Sims for her thoughtful insight regarding all aspects of Richard Pousette-Dart's art and career. I also extend my deepest gratitude to Evelyn Pousette-Dart for her recollections about Pousette-Dart's activities as a sculptor.

Richard Pousette-Dart's artistic development can best be described as precocious. Born in 1916, he appears to have grasped visual abstraction intuitively, executing fully abstract drawings when he was as young as ten years old. He articulated this orientation in a high school psychology essay, noting, "the greater the work of art, the more abstract and impersonal it is, the more it embodies universal experience, and the fewer specific personality traits is displays."[1] This deeply ingrained sensibility positioned Pousette-Dart as a seminal figure within the emergence of Abstract Expressionism during the 1940s. Essential to his journey was the immensely fertile decade of the 1930s when he sculpted in stone and brass and compiled a voluminous body of works on paper. Early drawings, in particular, reveal that this period of intense experimentation, synthesis, and transformation coalesced into a mature artistic vision that remained consistent in its affinity for abstraction throughout Pousette-Dart's long and remarkable career.

Pousette-Dart's formative artistic trajectory has been recounted by numerous scholars and justly emphasized are the influential roles of his parents, Nathaniel and Flora Pousette-Dart.[2] Of particular significance was his mother's vocation as a poet and her admiration for

1 Gail Levin, "Richard Pousette-Dart's Emergence as an Abstract Expressionist," *Arts Magazine*, vol. 54, no. 7 (March 1980): 125.
2 See Joanne Kuebler, "Richard Pousette-Dart," in Robert Hobbs and Joanne Kuebler, eds., *Richard Pousette-Dart* (Indianapolis, IN: Indianapolis Museum of Art, 1990) and Sam Hunter and Joanne Kuebler, eds., *Richard Pousette-Dart: The New York School and Beyond* (Milan, Italy: Skira, 2005).

the work of Ezra Pound; she introduced Richard to the American ex-patriot's imagist poetry and progressive artistic stance. Nathaniel Pousette-Dart's collection of non-Western art objects and multifaceted professional activities as an art director, writer, painter, printmaker, and educator provided his son with broad access to European, American, and so-called primitive art. During the mid-1930s, Nathaniel published *Art of Today* and *Art and Artists of Today*, magazines that examined topics in American regionalist and transatlantic avant-garde art and featured illustrations of African carving, American modernist sculpture, and European avant-garde painting. He additionally founded The Art Adventure League, a subscription-based visual arts training program whose instructors included such luminaries as Berenice Abbott and William Zorach. Underscoring the deep respect he held for his son's artwork even at this early stage, the elder Pousette-Dart featured sculpture and drawing by Richard in publications for these enterprises.[3]

Next, it is impossible to overlook the impact of Henri Gaudier-Brzeska, the French-born, British-based sculptor who died in Belgium during World War I at the age of twenty-three. As Gail Levin details, the young American artist's reverence for and subsequent disjuncture from Gaudier is key to understanding Pousette-Dart's emergence and maturation as an artist. Like Pound, Gaudier was associated with the Vorticist movement, and Pousette-Dart's close reading of the 1916 volume *Gaudier-Brzeska: A Memoir by Ezra Pound* served as an influential text. Not only did Gaudier's directly carved works in stone and wood fuel the aesthetic passions of the young American, but his advocacy for the unmediated expression of emotive forces exemplified by so-called primitive sculpture also resonated strongly with Pousette-Dart. Additionally, the compelling story of Gaudier's short life, popularized in the 1930s through published correspondence with his partner, Sophia Brzeska, likely stirred romantic associations for the emerging artist.

Pousette-Dart attended Bard College in 1935 but left before the end of his first semester to pursue a career as an artist in New York

3 Richard Pousette-Dart's *Tennessee Marble* appeared in *Art and Artists of Today*, vol. 1, no. 4 (Nov–Dec. 1937): 13. Three drawings appeared in Lesson No. 3, "Drawing from Nature," in the Drawing and Watercolor course edited by Lewis C. Daniel.

City. As he noted in 1937, "It was at this time that I first began to become seriously interested in sculpture. I spent all my time drawing, reading, writing, listening to music... I dreamed sculpture."[4] A six-month tenure in the studio of sculptor Paul Manship offered hands-on experience modeling stone, clay, and plaster, awakening "a passionate love for beautiful stone. I had carved stone before, but I did not have the great respect and love for it that commenced to grow within me then."[5] At the Manship studio, Pousette-Dart contributed lettering for the *Time and Fates of Man* sundial, destined for the 1939 World's Fair, but ultimately stood at odds with Manship's "artistic ideals and sculptural ends" and left to pursue carving independently in 1936.

Few of Pousette-Dart's 1930s sculptures are extant, but a small group of stone carvings, as well as a single work in ebony, and the cast bronze *Woman Bird Group* indicate that the artist concentrated largely on human figures, heads, and animal forms in his three-dimensional work of the period. *Tennessee Marble* of 1937, an abstracted kneeling figure, foregrounds the young artist's desire to convey "asymmetrical balance" and is indicative of his appreciation of the work of progressive European and American contemporaries [FIG. 2]. In addition to Gaudier-Brzeska, Pousette-Dart cited a number of modernist sculptors working in America as models— Gaston Lachaise, Ossip Zadkine, Reuben Nakian, and William Zorach—noting: "I am young, I shall yield to any influence that moves me strongly. I have no fear of the accusation of imitation; no two snowflakes that ever fell are alike."[6] We know through documentation, for example, that Pousette-Dart examined Lachaise's *Head of a Woman* of 1935 first-hand as he developed his own series of abstracted heads in faceted outline.[7]

4 "My Life in Brief," 1. September 4, 1937. Richard Pousette-Dart Papers; The Richard Pousette-Dart Foundation.

5 Ibid., 2.

6 Ibid.

7 Two photographs in the Nathaniel Pousette-Dart papers; The Richard Pousette-Dart Foundation, show Richard attending a gallery exhibition where Lachaise's *Head of a Woman* is on view; one photograph shows Pousette-Dart examining the bronze closely. During the 1930s he additionally carved the elongated, mask-like *Head of Meditation* in the manner of Modigliani.

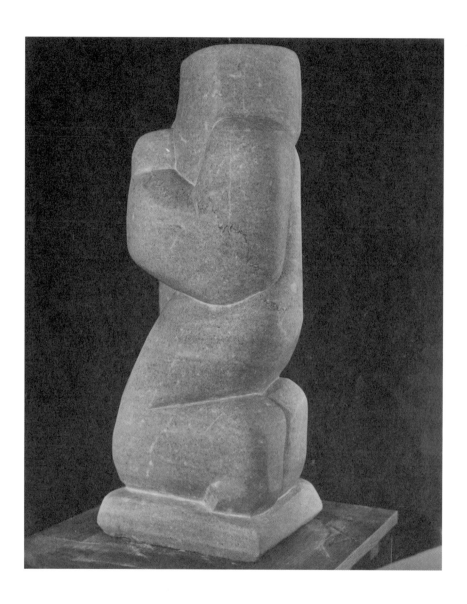

FIG. 2
Tennessee Marble, 1939

As Lowery Stokes Sims notes in her essay for this exhibition, the graphic output of Pousette-Dart from the 1930s is extensive and embraces sources as divergent as modernist American painting; African, Oceanic, and Northwest Coast Native American carving; mechanical gadgetry; and cinema. While a number of early drawings are traditional exercises in self-tutelage—sketches after old master paintings at the Metropolitan Museum of Art and anatomical studies executed at open drawing sessions at the Art Students League of New York—the majority, as Sims posits, are investigations into movement and volumetric form that partake in modernist conversations about geometry. These drawings also underscore the relationship between three- and two-dimensional media in Pousette-Dart's development. As he noted in 1939, "My drawings are my inspiration to carve direct; my assisting agents in departing from nature to a point of balance between nature and material form."[8]

Pousette-Dart's emphasis on sculpture can be observed in numerous drawings of figures attached to sculptural bases. One example distills Pre-Columbian imagery, utilizing narrow outline filled with watercolor in hues that suggest jade, a stone carved by Pousette-Dart during the early 1940s [PL. 52]. Another exhibits a command of broad, fluid ink brushstrokes to evoke the contours of an African Pahouin carving owned by John Graham that appeared in Zorach's printed foreword for the Art Adventure League [PL. 25]. Large, colorful drawings in conté, oil, graphite, and charcoal synthesize modernist approaches to three-dimensional figuration, especially as championed by Britain's Vorticist group, whose membership, in addition to Pound and Gaudier-Brzeska, included Jacob Epstein. The connection between Epstein's *Torso in Metal from Rock Drill* and Pousette-Dart's *Agony* [PL. 4] has been noted, and Epstein's monumental *Day*, unveiled in 1928 for the St. James Station of the London Underground, likely was a model for Pousette-Dart's frontal image of a woman with child [PL. 28].[9]

8 Artist's statement, January 13, 1939. Richard Pousette-Dart Papers; The Richard Pousette-Dart Foundation.

9 I want to thank Jennifer Powell, Senior Curator, Kettle's Yard, University of Cambridge, for identifying possible sources in Epstein's work. Powell has additionally noted similarities between Pousette-Dart's frontal woman with child [PL. 28] and Epstein's *Primeval Gods*, a 1933 large-scale relief on the reverse of Sun *God* of 1910.

While Richard Pousette-Dart possessed a deep familiarity with Vorticist sculpture and Nathaniel Pousette-Dart referenced Gaudier in *Art and Artists of Today*, in 1937, it is improbable that either had the opportunity to encounter actual works by artists of this group in New York City apart from Gaudier's *Birds Erect*, sold from the John Quinn Collection in 1927, and a collection of minor sketches by the French artist exhibited in 1935 alongside drawings by the sculptor Ivan Mestrovic.[10] Their most likely visual sources were periodical reproductions and H. S. Ede's annotated and illustrated compilation of Gaudier's correspondence, *Savage Messiah*, published in several editions during the 1930s.[11] As numerous early drawings by Richard Pousette-Dart clearly are two-dimensional explorations of Gaudier's sculptures *Red Stone Dancer*, *Bird Eating Fish*, and *Seated Woman*, it is likely that he had access to the lavishly-illustrated early edition of *Savage Messiah* printed in London, rather than the abridged American edition published in New York in 1931.

Additionally, Pound's volume on Gaudier offered an eloquent introduction to Vorticism's rejection of classically-based humanist and rationalist approaches to art production—especially the Greek notion of the idealized body—and championed instead the dynamic, irrational wellspring found in nature-based, non-Western sculpture, as well as the emotively-driven process of direct carving.[12] Robert Hobbs has astutely examined Pousette-Dart's artistic trajectory through a Vorticist lens, and Pousette-Dart's notebook entries from the late 1930s corroborate such a reading: "My sculpture will be built upon order/forms transmitting force referring to nature/Masses that inspire/ Complete in themselves and are eternal/the entity/the swirling mass/ the intensity/the naked truth/the vortex."[13] In the two-dimensional

10 *Birds Erect* entered the collections of the Museum of Modern Art in 1945.

11 Nathaniel Pousette-Dart's reference to Gaudier's poetry appears in *Art and Artist of Today* and has been pointed out by Innis Howe Shoemaker, "Line and Light: Richard Pousette-Dart's Art on Paper," in Shoemaker, ed., *Full Circle: Work on Paper by Richard Pousette-Dart* (Philadelphia, PA: Philadelphia Museum of Art, 2014).

12 For more on the movement, see Mark Antliff and Vivien Green, eds., *The Vorticists* (London: Tate Publishing, 2010).

13 Robert Hobbs, "Form is a Verb: Pousette-Dart and Vorticism," in *Richard Pousette-Dart: Drawing, Form is a Verb* (New York: Knoedler & Company, 2008), 5–12. B-1 286: This early orientation towards non-Western examples was further reinforced through Pousette-Dart's friendship with John D. Graham and familiarity with his influential book *System and Dialectics of Art*, published in 1937.

realm, Vorticism sought to capture not simply "tension of the body and form," but energy based in the *potential* for movement, especially through the massing of planes. In Pousette-Dart's highly abstracted image of a head [PL. 45], this strategy is explored through an assembly of curved, flat components inside a profile form, while other examples [PL. 24 and 47] utilize highly unstable figurative poses to forward unresolved, potential energy. Literal and emotive aspects of Vorticism remained paramount for Pousette-Dart through the early 1940s, as noted in his correspondence with H. S. "Jim" Ede, with whom he entered into a friendship in 1940: "Gaudier – A fine balance of feeling – intellect – which tends to *move* the observer's *whole* being. Gaudier's work is more Primal – Direct and with the harmonies of the workings of nature."[14]

A diverse array of Pousette-Dart's drawings from the 1930s explore the human figure engaged in action, exemplifying Gaudier's investigations into the idea of rhythm, as well as what Jennifer Powell describes as "rapid shifts between observed expressive realism and a vital abstraction of the body."[15] Gaudier created numerous studies based upon dance and wrestling, both which enjoyed explosive popularity in London during the early teens, and Pousette-Dart appears to have synthesized and expanded upon these subjects, executing a feverish program of related abstracted figurative drawing based upon American sources. Sculptural concerns remain omnipresent in a spirited image of a strongman flexing a resistance bar [PL. 16], as well as in one featuring intertwined wrestlers based upon non-Western sources set within a spatially shallow field [PL. 56]. In *Walking Man* [PL. 2], *The Lovers II* [PL. 1], and an additional example [PL. 26], Pousette-Dart reduced figural components to flattened geometric planes, indicating a progression towards complex compositions comprised of interlocking shapes that came to define, in part, his Abstract Expressionist painting. Several drawings are abstracted from images of American football, which Pousette-Dart played in high school, and it is likely that many of his studies of dance and

14 In a letter dated November 17, 1940. Archives, Kettle's Yard, University of Cambridge.

15 Jennifer Powell, "In Search of NEW RHYTHMS," in Powell, ed., *New Rhythms: Henri Gaudier-Brzeska* (Cambridge, England: Kettle's Yard, University of Cambridge, 2015), 23.

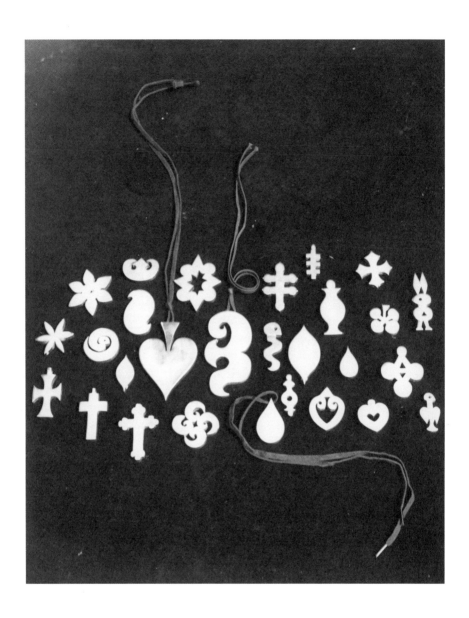

FIG. 3
Selection of brasses photographed by Richard Pousette-Dart, c. 1945

theatrical action were derived from first-hand observation [PL. 27]. Pousette-Dart's marriage to dancer and model Blanche Grady during the late 1930s offered opportunity to draw modernist dance from life, including at formal practices for programs founded by Florence Fleming Noyes and at performances of the Student's Dance Recital Organization directed by modern and avant-garde choreographers Helen Tamiris and Miriam Marmein.[16]

Simple geometric and reduced organic forms fascinated Pousette-Dart from an early age, appearing both within his early photographic experiments and elementary drawings. By the late 1930s, such forms were approached as individual images within Pousette-Dart's drawing, and both base and embellished elemental shapes were studied systematically relative to perceived emotive qualities, spurring the artist to propose preparation of a book titled *The Spirit of Forms*. During this time, Pousette-Dart also began crafting small, hand-cut, non-figurative sculptures in brass, a practice most likely inspired by Pound's volume on Gaudier in which the author describes Gaudier's "[s]everal purely geometric abstractions…, cut-brass door-knockers…, and a very small brass fish." Pousette-Dart would go on to create more than 100 pocket-sized brass sculptures throughout his lifetime, many crafted for specific individuals where symbols or designs were imbued with meaning relative to intended recipients [FIG. 3]. As he noted in the late 1930s, "I base my designs on forms in nature and organic symbols that people variously seem to embody."

With significance for Pousette-Dart's painting, Pound in his *Memoir…* recalled one of his last conversations with Gaudier before the French artist's untimely death:

"His conclusion after these months of thought and experiment, was that combinations of abstract and inorganic forms exclusively were more suitable for painting than sculpture. Firstly, because in painting we can have a much greater complexity, a much greater number of form units than in sculpture…

16 Pousette-Dart may also have been familiar with Abraham Walkowitz's prolific series of drawings of Isadora Duncan.

Secondly. The field of combinations of abstract forms is nearly unexplored in occidental painting whereas machinery itself has used up so many of the fine combinations of three dimensional inorganic forms that there is very little use in experimenting with them in sculpture."[17]

Gaudier died before his directives could come to fruition, yet Pousette-Dart's painting would, in large part, fulfill the promise of the Frenchman's program. By 1941, the year of his first one-man exhibition at New York City's non-profit Artists' Gallery, Pousette-Dart had assimilated and begun to transcend the groundwork of avant-garde artists of the opening decades of the twentieth century. His sustained interest in geometric and organic forms world ultimately inform his painting, which became Pousette-Dart's primary medium beginning in the 1940s, and appear as the formative matter of both his complex, layered canvases of the Abstract Expressionist era and simplified compositions of the 1960s, 1970s, and 1980s.

17 Ezra Pound, *Gaudier-Brzeska: A Memoir by Ezra Pound* (London, 1916), 16.

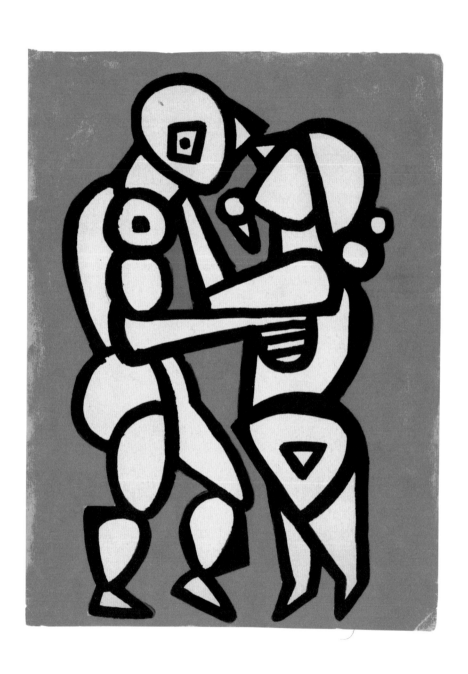

PL. 1
The Lovers II, 1930s

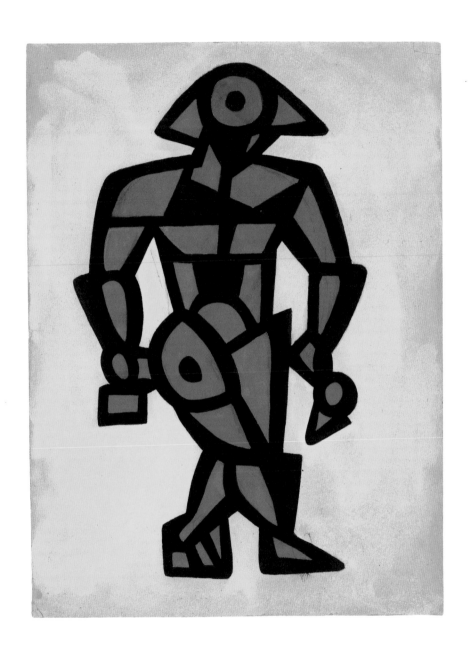

PL. 2
The Walking Man, 1930s

Richard Pousette-Dart's Drawings in the 1930s: Context and Content

Lowery Stokes Sims

* Thanks goes to Joanna Pousette-Dart for the invitation to write about an aspect of her father's work that I had not engaged before. I also want to express my profound gratitude to Charles Duncan, Executive Director of the Richard Pousette-Dart Foundation, who generously provided research materials that were indispensible to the completion of this essay. I additionally benefited greatly from our conversations about the artist's work and his father's endeavors to promote American art.

In a notebook he kept during the 1930s, Richard Pousette-Dart wrote, "Geometric form is the sculptural abstract means of revealing the greater truth of natural reality."[1] This statement reflects tendencies in early-twentieth-century modern art that investigated not only geometry's potential to present altered reality, but also its capacity to express ages-old ideas about the symbolic dimension of form. It is within this context that certain artists from the Cubist and Purist movements turned to the venerable notion of the Golden Section or Mean with its theory of proportional idealism.[2] It is along similar lines that the analyses of Amédée Ozenfant[3] and Herbert Read, W. G. Archer, and Robert Melville found inspiration in the idea that our ancestors held the secrets of the symbolic meaning of forms that were explored by modern artists.[4] For these artists, critics, and historians, geometry and its systems of scale and proportion could accommodate the ambitions of modern art to advance beyond illusionistic representation while serving as a conduit for the revelations that emerged from the spontaneous workings of the unconscious.

1 Richard Pousette-Dart, Notebook B-8 (c. 1938), 3. Richard Pousette-Dart Papers; Estate of Richard Pousette-Dart.

2 See for example, Cécile Debray and Françoise Lucbert, *La Section d'or, 1912-1920-1925* (Paris: Musées de Châteauroux, Musée Fabre, and Éditions Cercle d'art, 2000) and John Cauman, *Inheriting Cubism: The Impact of Cubism on American Art*, 1909–1936 (New York: Hollis Taggart Galleries, 2001).

3 See Amédée Ozenfant, *Foundations of Modern Art*, John Rodker trans. (New York: Dover Publications, Inc., 1952 [originally published in 1931]).

4 Herbert Read, W.G Archer, and Robert Melville, *Forty-thousand Years of Modern Art: A Comparison of Primitive and Modern* (London: Institute of Contemporary Art, 1947).

But most importantly for many, geometry affirmed and demonstrated the "universality of art, and, more particularly, the eternal recurrence of certain phenomena in art, which on their appearance, are labeled 'modern'."[5] This would legitimize modern art for the skeptical for, after all, as Robert Lawlor observed, "when many ancient cultures chose to examine reality through the metaphors of geometry…they were already very close to the position of our most contemporary society."[6]

Created, incredibly, in the immediate years after the artist graduated from high school, the drawings in this exhibition indicate how this connection between the modern and the eternal fired the imagination of Pousette-Dart in the 1930s. As Charles Duncan discusses in his essay, Pousette-Dart was initially drawn to sculpture. He apprenticed under Paul Manship and was particularly influenced by the work of the French-born, British-based sculptor Henri Gaudier-Brzeska—one of a cohort of modern artists working in the first decades of the twentieth century who discovered abstracted form through their appreciation of the tribal arts of Africa and the Pacific. This connection with European modernism is an important element in understanding the environment within which Pousette-Dart developed as an artist.

Today's art world with its global perspective stands in stark contrast to that of the United States between the two World Wars and particularly during the 1930s. The dramatic ups and downs of political, economic, and social aspects of society and, above all, the Great Depression marked the struggle to set priorities for this country. They encouraged a widespread looking inward in American art and an antagonism toward the ideals of European modernism. This, despite the fact that the Armory Show introduced European modernism to a large audience in the United States in 1913 and the fact that numerous Americans artists—Thomas Hart Benton and Stanton MacDonald-Wright among them—had spent time in Europe absorbing the lessons of various manifestations of modernism.

5 Ibid, 6.
6 Robert Lawlor, *Sacred Geometry: Philosophy and Practice* (London: Thames & Hudson, 1982), 4.

Figures such as Hart Benton (who retreated from his early flirtation with abstraction during his European sojourn) and the critic Thomas Craven vociferously promoted the idea that American art should reflect the experience of its ordinary citizens. In their view, a focus on artistic expression that existed for its own sake would jeopardize a sense of national identity. Purporting to speak in the name of democratizing American art, they condemned abstract modes as foreign to everyday Americans. It was up to key individuals such as Pousette-Dart's father, Nathaniel, the protean sculptor and social activist Stuart Davis, and the artists associated with the American Abstract Artists group to promote a less parochial perspective on modern art. Adherents to modernism in Europe found themselves increasingly marginalized—even suppressed—as fascist regimes attained social and political ascendency and began to immigrate to the United States in large numbers. Their presence would also be instrumental in expanding American art's engagement with modernism and abstraction. Pousette-Dart's mentorship under his parents,[7] his study of the work of Henri Gaudier-Brzeska, and his acquaintance with the influential Russian émigré and gadfly John Graham (who was equally interested in "primitive" art and "the role of intuition and the unconscious in artistic creation"[8]) was the context in which his precocious artistic development occurred.

Pousette-Dart's drawings indicate his direct observation and analysis of African, Oceanic, and Native American art first hand at the American Museum of Natural History in New York City. While he rarely closely copied what Joanne Kuebler described as the "ancient geometric forms"[9] in this art, his drawings reflect an appreciation of their ability to conjure power, belief, and mystery. As he observed cryptically in another of his notebooks, "mystic language/ of shapes/ of form as shapes/ of shape as form."[10] As seen in two untitled works,

7 A poet, Pousette-Dart's mother was also an advocate of modernism and introduced her son to the work of Ezra Pound.

8 Innis Howe Shoemaker "Line and Light: Richard Pousette-Dart's Art on Paper," in Shoemaker, ed., *Full Circle: Work on Paper by Richard Pousette-Dart* (Philadelphia, PA: Philadelphia Museum of Art, 2014), 85.

9 Joanne Kuebler, "Richard Pousette-Dart," in Robert Hobbs and Joanne Kuebler, eds., *Richard Pousette-Dart* (Indianapolis, IN: Indianapolis Museum of Art, 1990), 84.

10 Richard Pousette-Dart, Notebook B-171 (c. 1930s), 27. Richard Pousette-Dart Papers; Estate of Richard Pousette-Dart.

the more schematic renderings in Pousette-Dart's drawings recall the geometric forms of utensils, adornments, and human surrogates that one might discover in a ceremonial hoard [PLS. 53–54]. (These, in turn, anticipate the eccentric shapes in his 1950 painting *Path of the Hero*). A hieratically frontal mother and child evokes African art [PL. 28]. Intimations of the work of the British sculptor Henry Moore can be seen in *Untitled* [PL. 54] and *Untitled* [PL. 60], with their open torsos under their breastplates and their encircling, enclosing arms circle. Other totemic entities are comprised of stacked elemental forms that appear as much mechanistic as biomorphic.

Some of the most striking images in this body of work are heads and figures rendered in strong, thick black lines that critic John Yau relates to the schematic aspects of Pablo Picasso's 1930s work (seen, for example, in *Girl Before the Mirror*, 1932).[11] As Innis Howe Shoemaker writes, the images are "composed of complex interlocking networks of abstract and geometric shapes."[12] This parallels William Zorach's analysis of the human body in simple geometric shapes in "The Language of Sculpture," which appeared in a newsletter from the Art Adventure League—the subscription project conceived by Pousette-Dart's father Nathaniel in an effort to bring a familiarity with art to a wider public. As Charles Duncan cites in his essay, the elder Pousette-Dart even featured some of his son's early sculptures in his other publications: *Art of Today* and *Art and Artists of Today*.[13]

Reminders of Pousette-Dart's early work with Paul Manship appear in studies of wrestlers. In one [PL. 26], a wrestler raises his opponent just before flinging him to the mat. In another [PL. 27], the athlete assumes a confrontational hands-on-thighs stance. Other head and figural studies reflect an approach to human physiognomy as a metaphor for societal angst as seen in the masklike and occasionally contorted character of *Untitled* [PL. 45] and *Mythic Head of*

11 John Yau, "Impersonal Truths," in *Richard Pousette-Dart: Mythic Heads and Forms, Paintings and Drawings from 1935 to 1942* (New York: Knoedler & Company, 2003), 6. It is pertinent to note that this painting entered the collection of the Museum of Modern Art in 1938.

12 Shoemaker, op. cit., 83.

13 Nathaniel Pousette-Dart papers; The Richard Pousette-Dart Foundation. I appreciate Charles Duncan sharing this information with me.

a Woman [PL. 37]. Art historian Gail Levin has proposed that these are Pousette-Dart's empathetic response to the intimations of the resumption of global war in the late 1930s.[14]

Perhaps this response to world events also informed Pousett-Dart's taste for tales of transmuted humans popularized in films starring Lon Chaney and Lon Chaney, Jr. in the 1920s and 30s, which can be seen in studies of supra-human, hulking figures such as *Agony* [PL. 4] and *Untitled (Egor the Monster)* [PL. 46]. Other examples such as *Untitled* [PL. 24] and *Man, Sun* [PL. 3] are reminiscent of the humanoid mechanism seen in *Metropolis*, and—given the associations with the British Vorticist movement that Robert Hobbs suggests in relation to Pousette-Dart's early work[15]—the machine/human hybrid figures created in the 1910s by British sculptor Jacob Epstein. Additionally, given what Charles Duncan described as Pousette-Dart's fascination with mechanical objects,[16] what is known as "gadget science fiction" (where humankind deals with the consequences of ill-conceived or hubristic scientific invention)[17] is another plausible reference for Pousette-Dart's work at this time.

In these images, Pousette-Dart uses line to build form, which was also the basis of the work of his older contemporary Stuart Davis during the 1930s. Davis developed a personal artistic vocabulary in which line became the primary element to create spatio-temporal tensions that distilled the essential character of the nautical and urban scenes his favored.[18] As noted above, Davis was a fellow traveler with Nathaniel Pousette-Dart and a photograph of him in front of his 1930 painting *Summer Landscape* (Museum of Modern Art, New York) appeared in the feature "The Artist and His Work

14 Gail Levin, "Richard Pousette-Dart's Emergence As an Abstract Expressionist," *Arts Magazine*, vol. 54, no. 7 (March 1980): 127.

15 Robert Hobbs, "Form is a Verb: Pousette-Dart and Vorticism," in *Richard Pousette-Dart: Drawing, Form is a Verb* (New York: Knoedler & Company, 2008), 5–12.

16 Charles H. Duncan, *Absence/ Presence: Richard Pousette-Dart as Photographer* (Utica, NY: Munson Williams Proctor Arts Institute, 2014), 10. My conversations with Charles Duncan were essential for the clarification of these ideas.

17 See http://genius.com/Isaac-asimov-three-types-of-science-fiction-stories-annotated.

18 Lowery Stokes Sims, "Stuart Davis in the 1930s: A Search for Social Relevance in Abstract Art," in Sims, et al., *Stuart Davis, American Painter* (New York: The Metropolitan Museum of Art and Harry N. Abrams, Inc., 1991), 58.

are of One Piece" in the November/December, 1937 issue of *Art and Artists Today*.[19]

Shoemaker observes that in the late 1930s, as Pousette-Dart segued from sculpture to painting, he began to combine his more geometric forms with "free, intuitive drawings" to "initiate densely layered compositions" in which "finely drawn abstract and organic images were overlaid and partially obscured by multiple applications of different materials and colors."[20] This can be seen in paintings such as *East River* of 1939 and would reach full efflorescence in *Symphony Number One: The Transcendental* of 1942. This latter canvas is widely recognized as the first painting that could be considered an Abstract Expressionist work, both in terms of its scale and its iconography, which features shapes that reflect the ancient hatchet/axe forms, incipient heads, bird contours, and egg/seed forms first seen in the drawings in this exhibition.

Pousette-Dart's prescient work of the late 1930s anticipates the primitivist interests of American modernists in Native American culture that culminated in the 1940s. In his essay for the 1947 exhibition *The Ideographic Picture* at the Betty Parsons Gallery in New York, Barnet Newman reprised some of Pousette-Dart's musings of a decade earlier that the geometric was a vehicle "revealing the greater truth of natural reality." Newman extolled the virtues of the art of the indigenous peoples of the North American Northwest noting particularly that shapes of Kawkiutl [i.e. Kwakwaka'wakw] art were "living" things, vehicles for "an abstract thought complex, a carrier of the awesome feeling that he felt before the terror of the unknowable."[21]

These ideas would find the most specific manifestation in the work of painters such as Steve Wheeler, Peter Busa, Robert Barrell, Howard Daum, and Will Barnet, who were collectively known as the Indian Space Painters. As Barbara Hollister writes,

19 "The Artist and His Work are of One Piece," *Art and Artists of Today*, vol. 1, no. 4 (November/ December, 1937): 9. Nathaniel Pousette-Dart papers; The Richard Pousette-Dart Foundation.
20 Shoemaker, op. cit., 84.
21 Barbara Rose, ed., *Readings in American Art since 1900: A Documentary Survey* (New York and Washington DC: Frederick A. Praeger, Publishers, 1968), 145.

this group—influenced by émigré Surrealist artists—"found in Northwest coast ideographic art the basis of a pictorial language in which image, symbol, and myth coalesced, functioning simultaneously as art form, historical narrative, and religious icon." They were thus "engaged in one of the seminal issues of early abstraction: the merging of language and image."[22]

For Pousette-Dart, his work in the 1940s continued to manifest that combination of geometry and "free intuitive" drawing. His penchant for the grid and the continuity of his affinity for geometry distinguished his work from what became canonical Abstract Expressionism, but it served him well as he worked through what he described in the 1930s as "the inner language" of the "mind's spirit."[23] In fact, it allowed his art to anticipate and complement a succession of stylistic tendencies into the 1980s (including color field painting, Minimalism, and a glyphic neo-primitivism) all the while maintaining his unique identity and presence, defying the classification he resisted throughout his life.

22 Barbara Hollister, "Indian Space: History and Iconography," in *The Indian Space Painters: Native American Sources for American Abstract Art* (New York: Baruch College of the City University of New York, 1991). http://www.barbarahollister.com. Precedents for these forays into the forms and philosophy of Native American art can be found in the work of artists such as John Marin and Marsden Hartley, who were drawn to the cultures of the Southwestern United States in the 1920s and 1930s. This effectively shifted the focus of primitivist infatuation from Africa and the Pacific to more "homegrown" influences from Native America.
23 Richard Pousette-Dart, Notebook B 67, 1930s. Richard Pousette-Dart Papers; The Richard Pousette-Dart Foundation.

"my aim is to create a fine balance between stone forms and nature, an asymmetrical balance, parallel to nature, between naturalistic form and pure geometric abstraction."

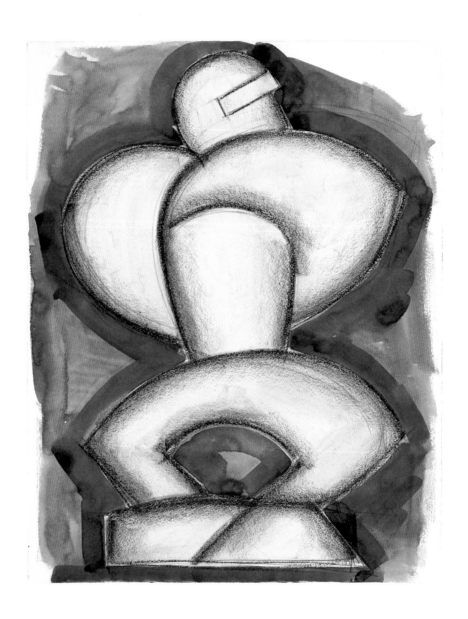

PL. 3
Untitled, 1930s

PL. 4
Agony, 1930s

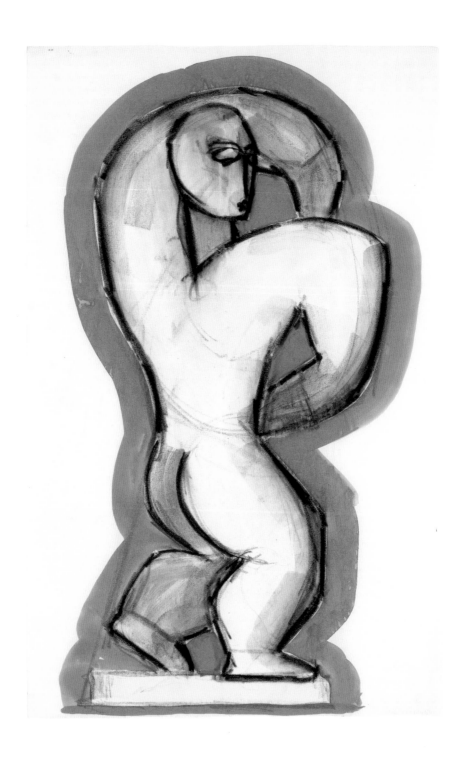

PL. 5
Untitled, 1930s

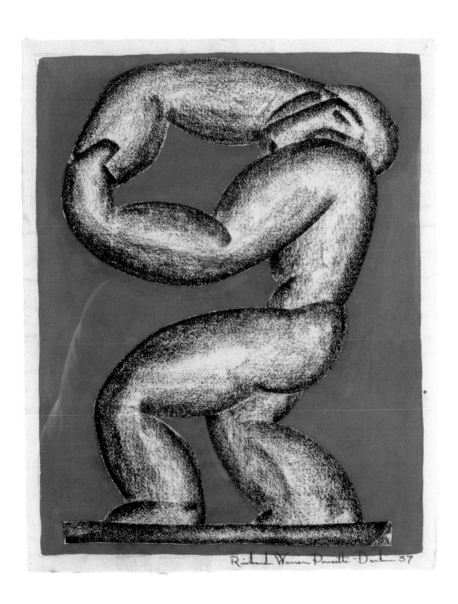

PL. 6
Untitled, 1937

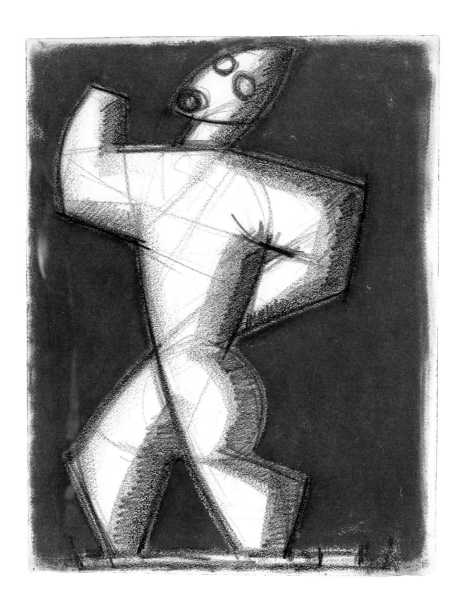

PL. 7
Untitled, 1930s

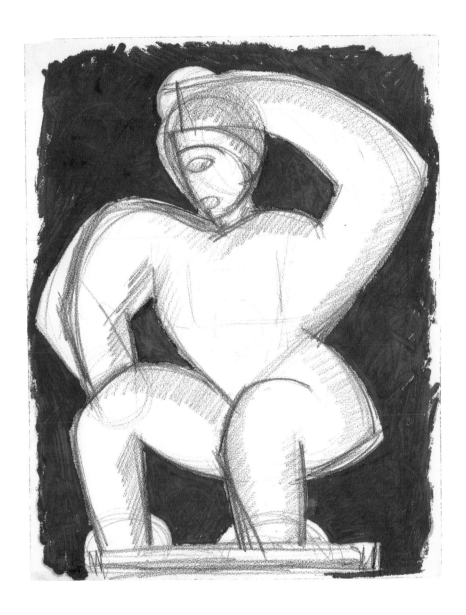

PL. 8
Untitled, 1930s

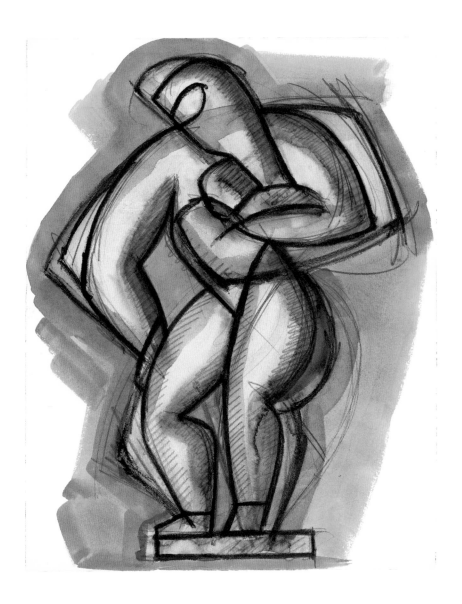

PL. 9
Untitled, 1930s

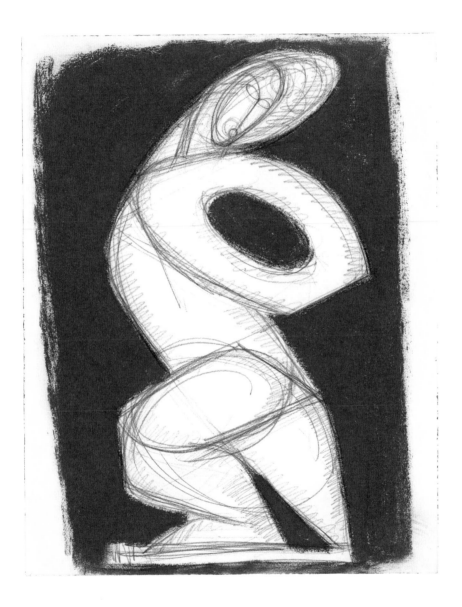

PL. 10
Untitled, 1930s

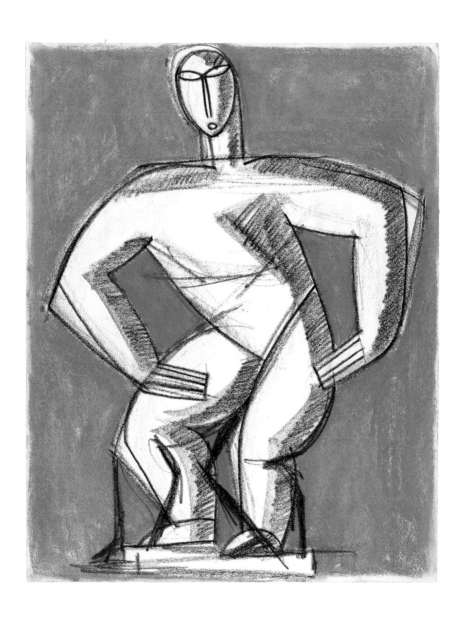

PL. 11
Untitled, 1930s

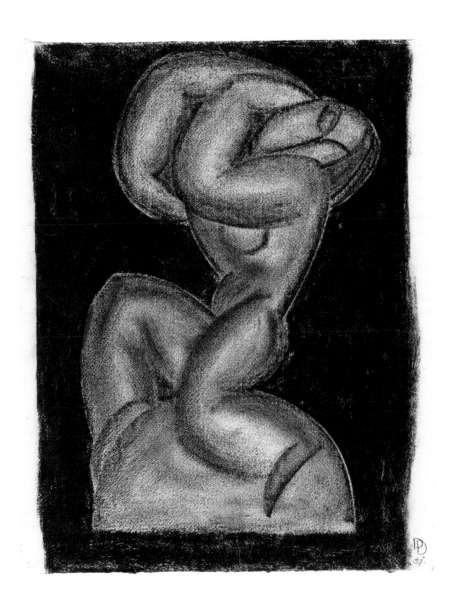

PL. 12
Untitled, 1937

"the measure of a drawing is not its technique but what is meant within its spirit—what you are striving to say with your line."

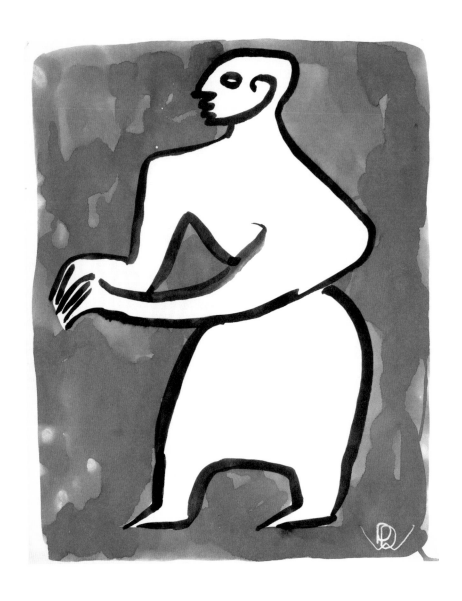

PL. 13
Untitled, 1930s

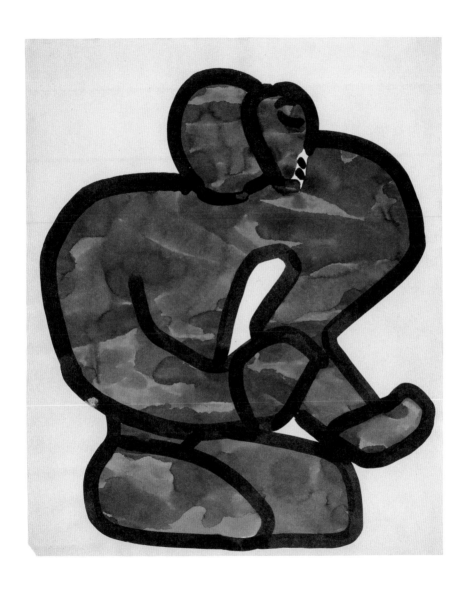

PL. 14
Untitled, 1930

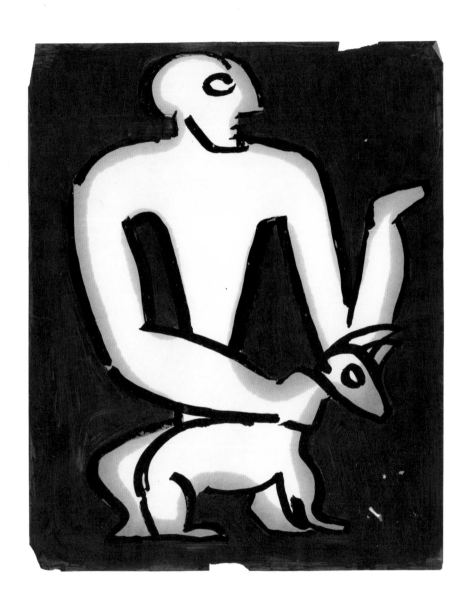

PL. 15
Untitled, 1930s

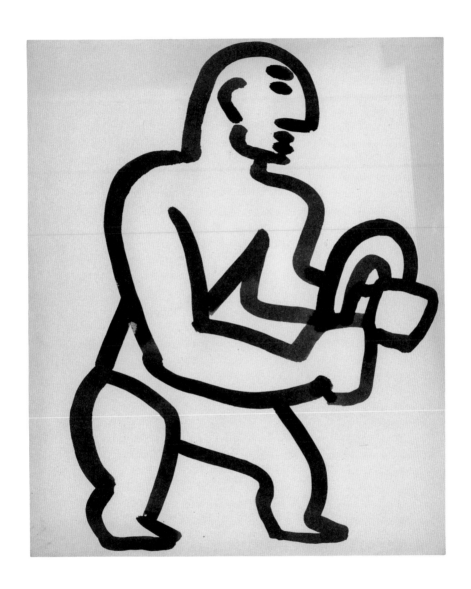

PL. 16
Untitled (Two Figures), 1930s

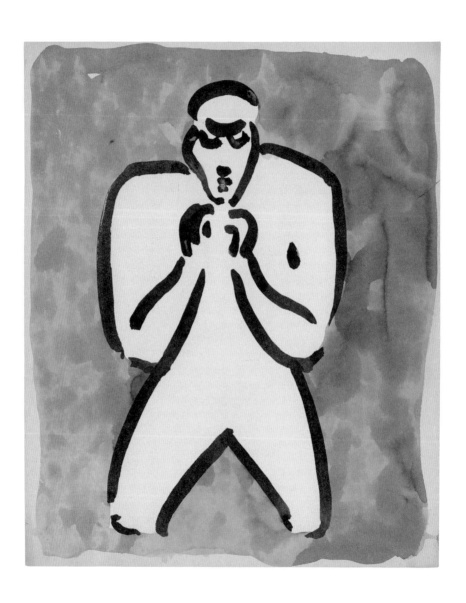

PL. 17
Untitled, 1930s

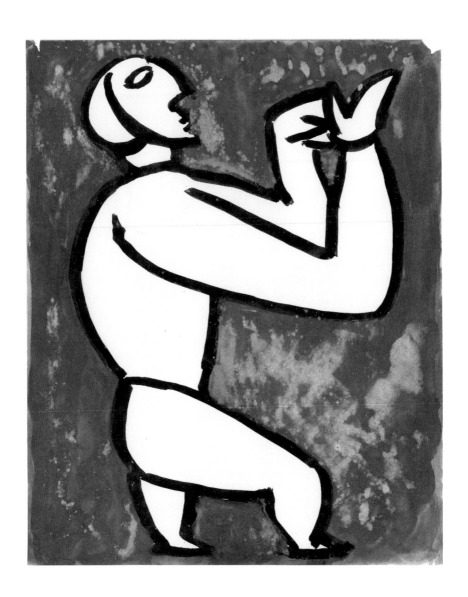

PL. 18
Untitled, 1930s

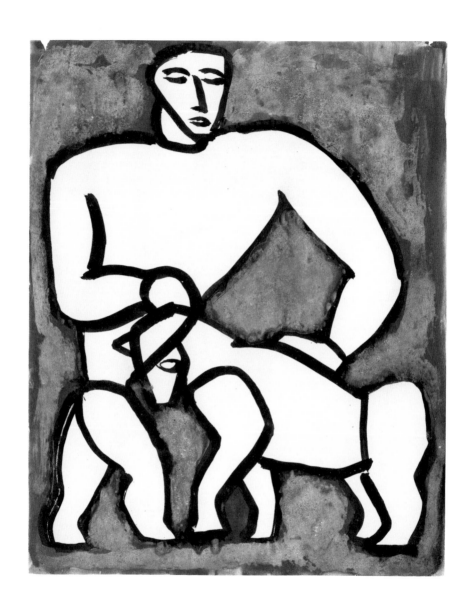

PL. 19
Untitled, 1930s

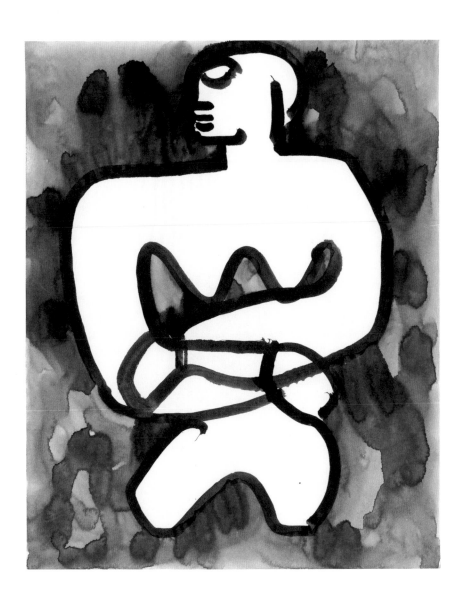

PL. 20
Untitled, 1930s

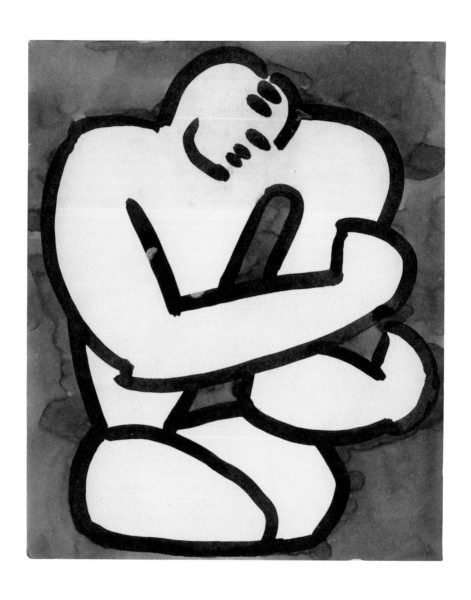

PL. 21
Untitled, 1930s

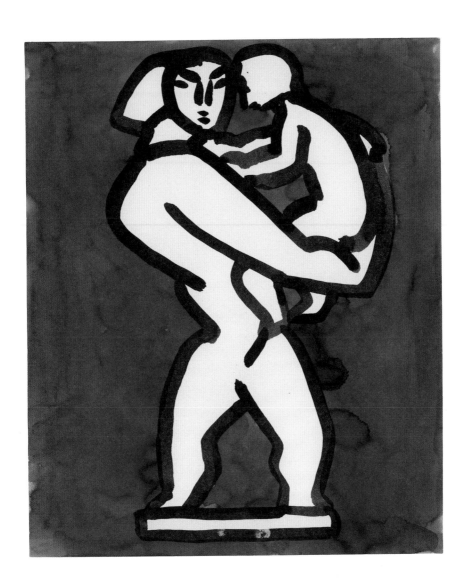

PL. 22
Untitled, 1930s

"edges and lines speak
tell more than stories
a language beyond words."

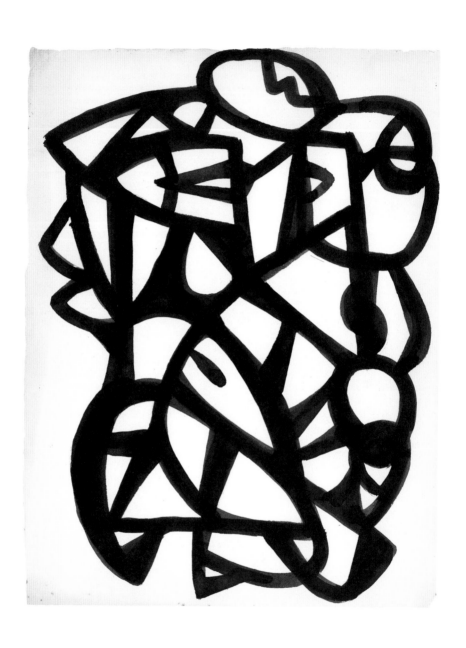

PL. 23
Untitled, 1930s

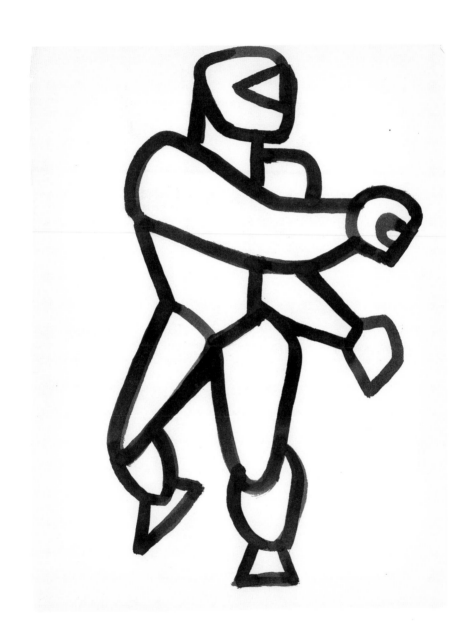

PL. 24
Untitled, 1930s

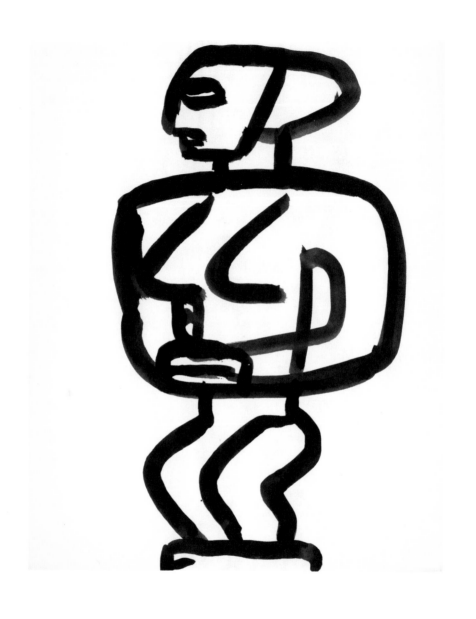

PL. 25
Untitled, 1930s

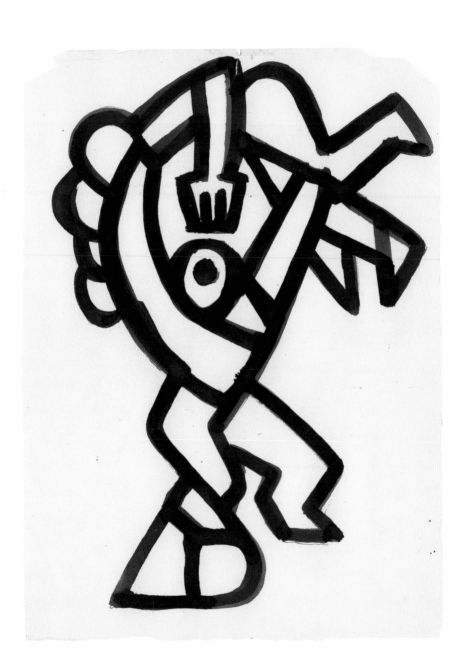

PL. 26
Untitled, 1930

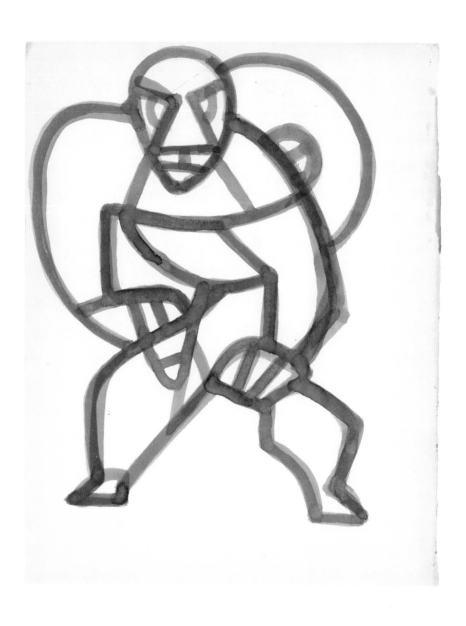

PL. 27
Untitled, 1930s

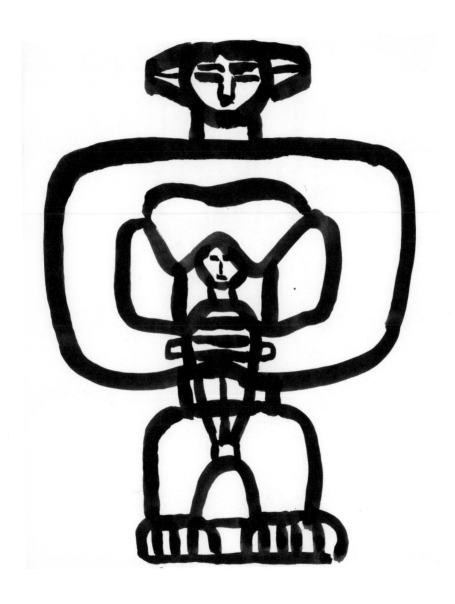

PL. 28
Untitled, 1930s

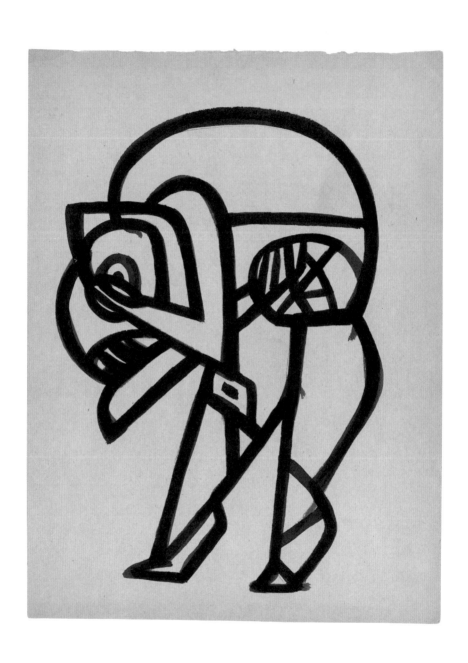

PL. 29
Untitled, 1930s

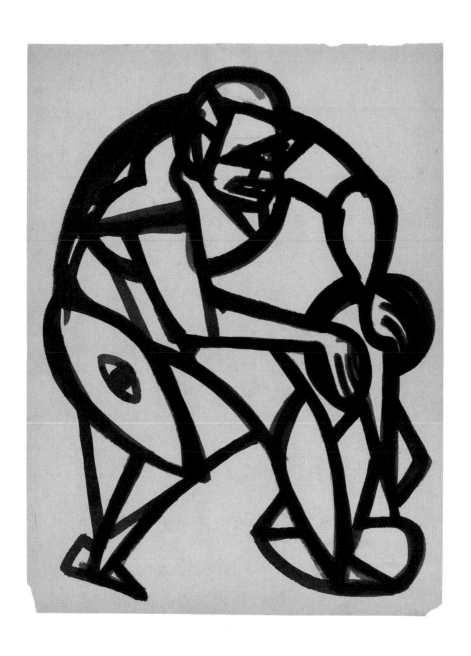

PL. 30
Untitled, 1930s

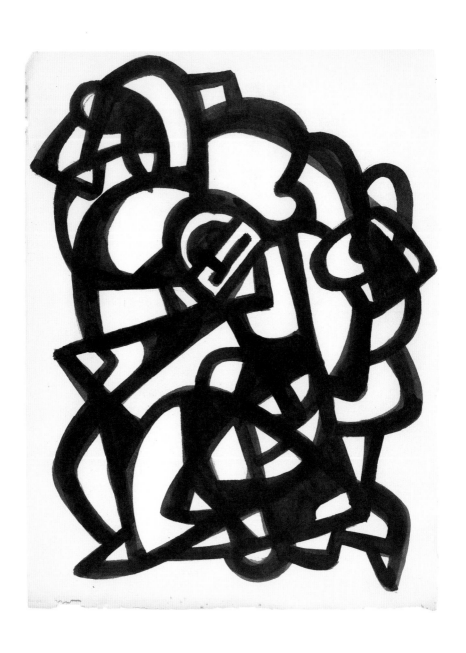

PL. 31
Untitled, 1930s

"each face in its own light is a poem."

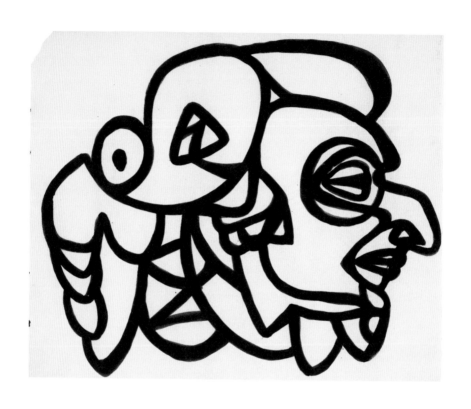

PL. 32
Untitled, 1930

PL. 33
Untitled, 1930s

PL. 34
Untitled, 1939

PL. 35
Untitled, 1930s

PL. 36
Untitled, 1930s

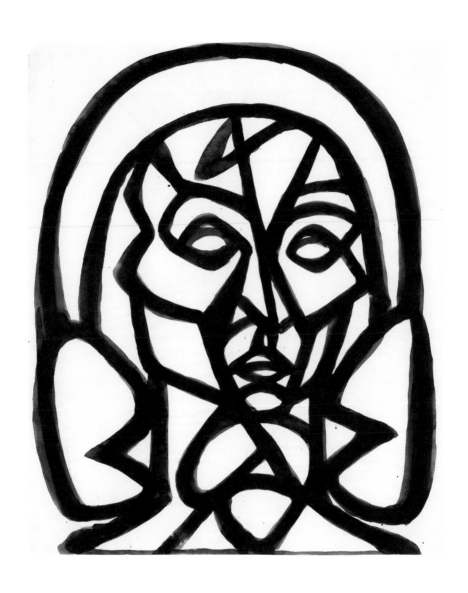

PL. 37
Mythic Head of a Woman, 1930

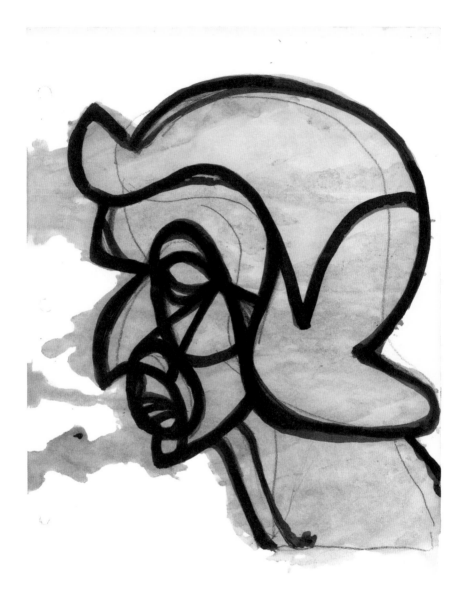

PL. 38
Untitled, 1930s

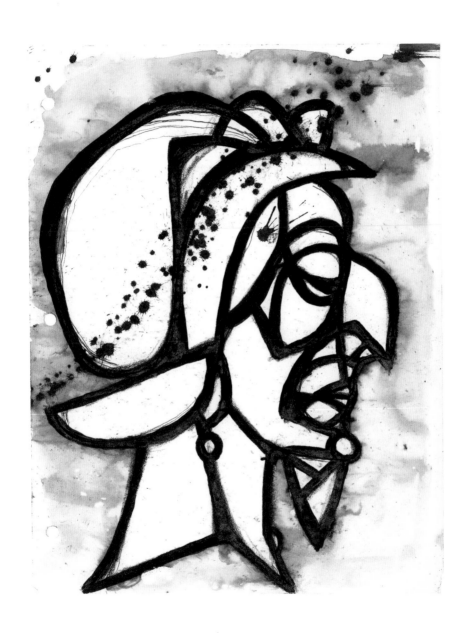

PL. 39
Untitled, 1930s

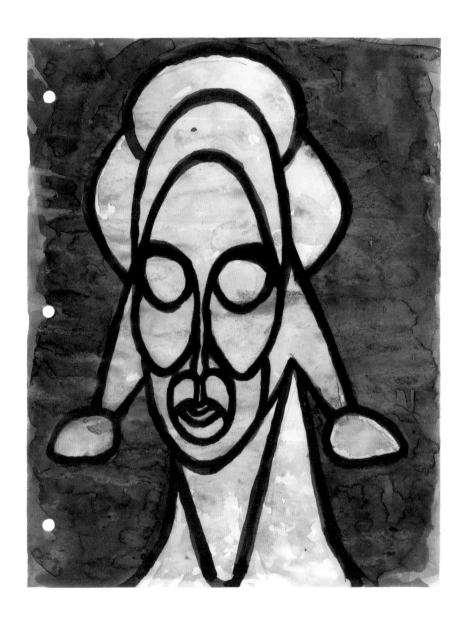

PL. 40
Untitled, 1930s

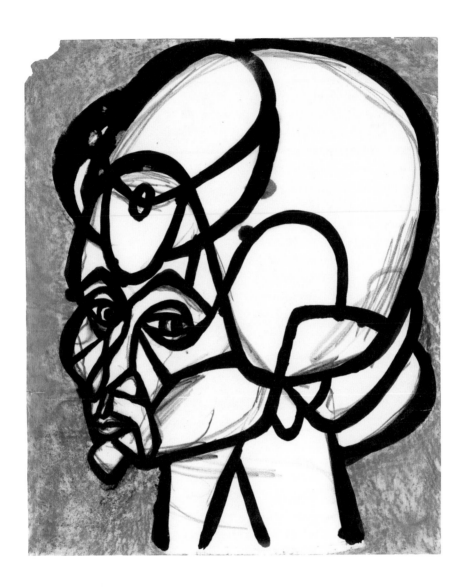

PL. 41
Untitled, 1930s

"I seek to create figures, symphonies, architecture of near pure forms composed of lines and planes, referring to the bodies of men and animals, forms feeling the abstract, yet carrying the emotional drive of reality."

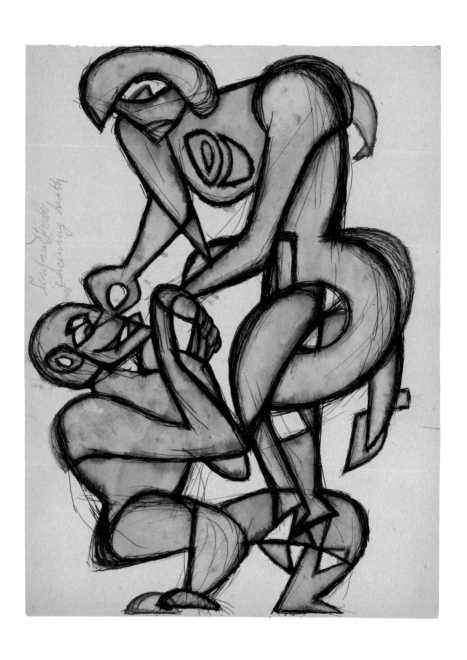

PL. 42
Untitled (L'Enfant Terrible Perceiving Death), 1935

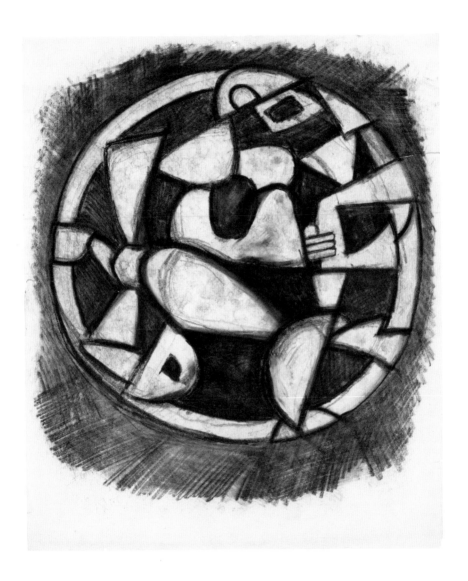

PL. 43
Untitled, 1930s

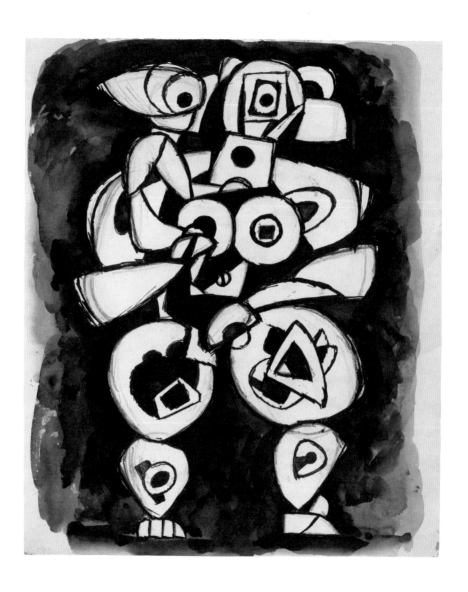

PL. 44
Two Figures, 1930s

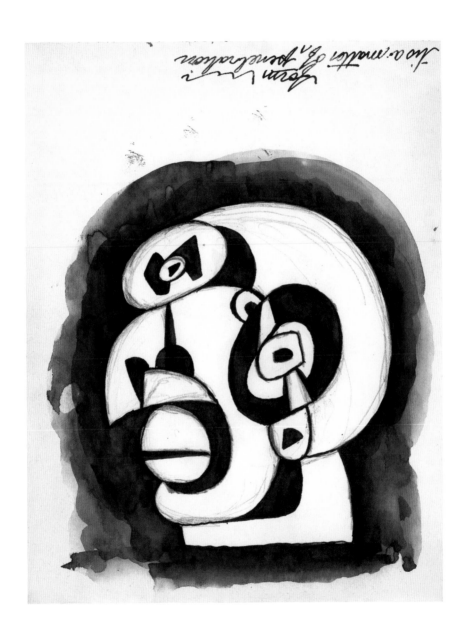

PL. 45
Untitled, 1930s

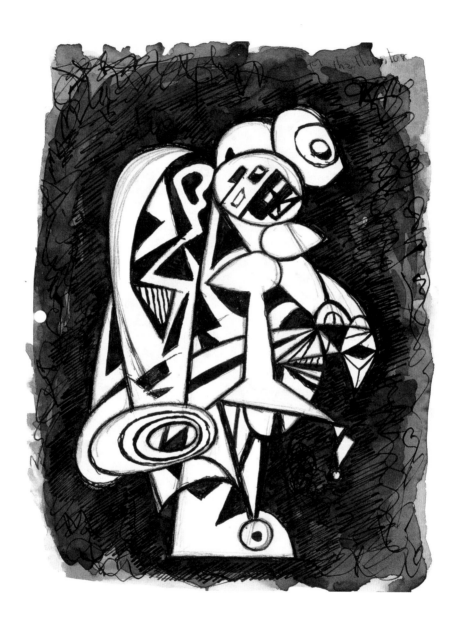

PL. 46
Untitled (Egor the Monster), 1939

PL. 47
Untitled, 1930s

"My drawings are abstracted from various aspects of nature. Each of them is a prospective sculptural essence; they are conceived form enhancements, maturities, multiplications, intensifications of forms inspired by nature..."

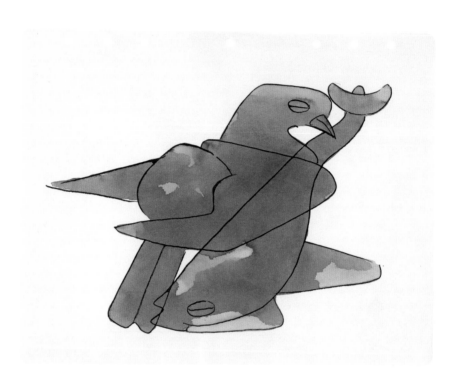

PL. 48
Untitled, 1930s

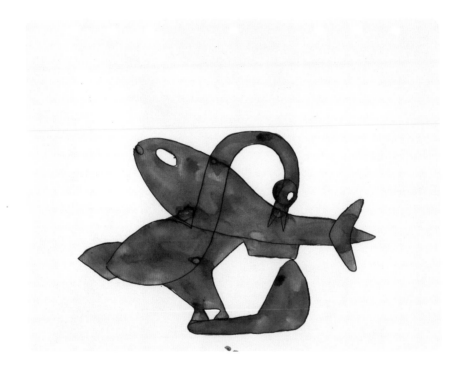

PL. 49
Untitled, 1930s

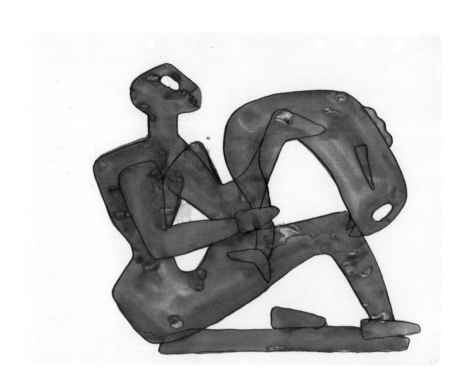

PL. 50
Untitled, 1930s

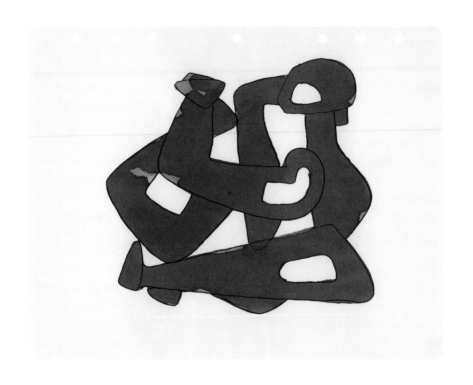

PL. 51
Untitled, 1930s

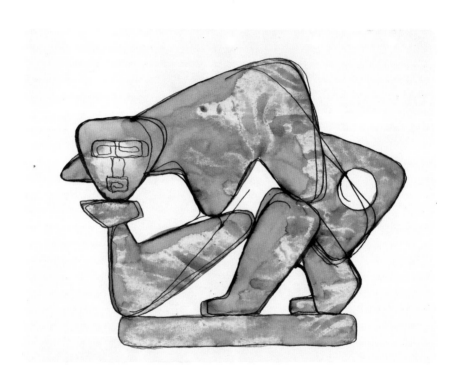

PL. 52
Untitled, 1930s

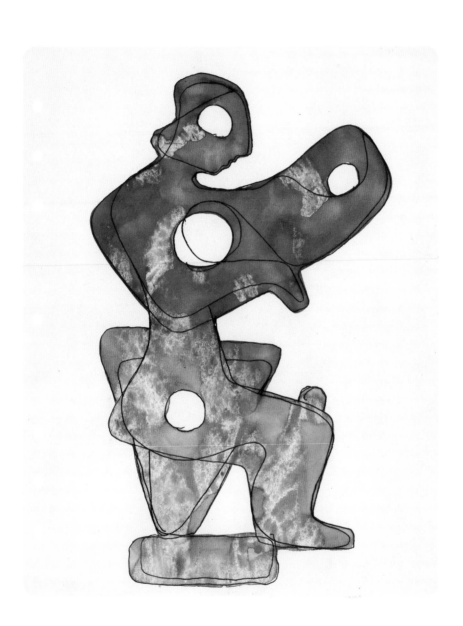

PL. 53
Untitled, 1930s

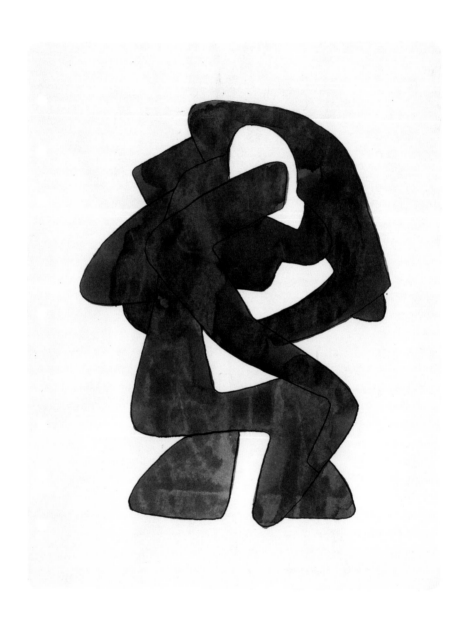

PL. 54
Untitled, 1930s

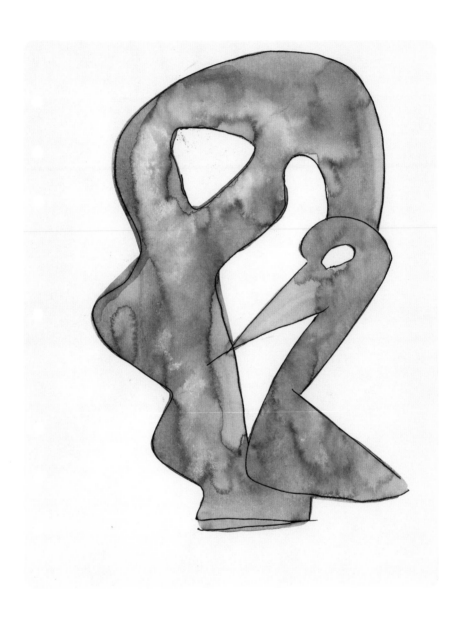

PL. 55
Untitled, 1930s

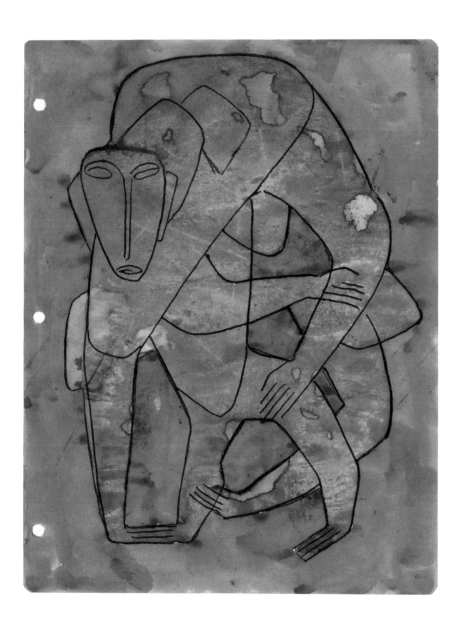

PL. 56
Untitled, 1930s

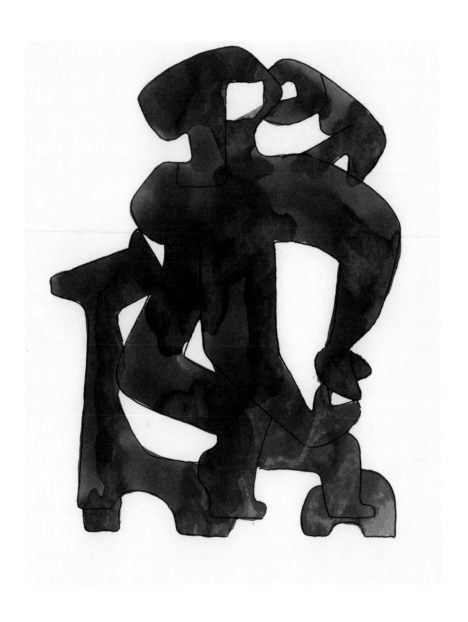

PL. 57
Untitled, 1930s

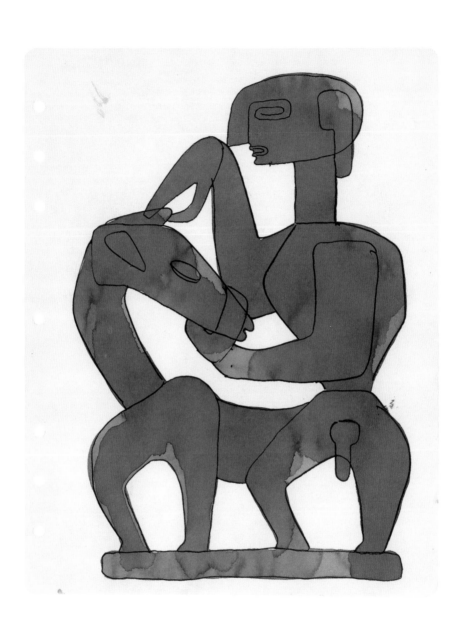

PL. 58
Untitled, 1930s

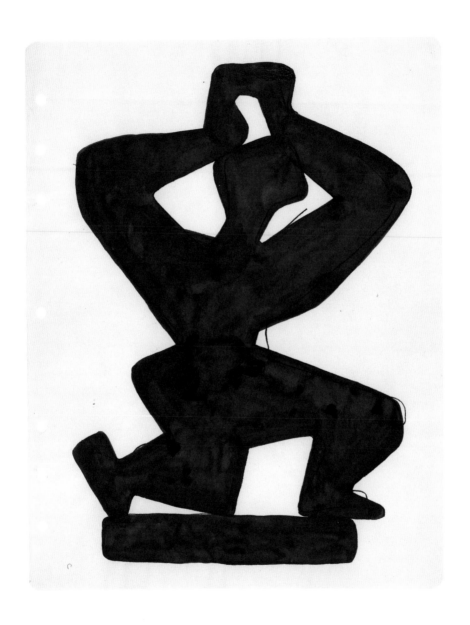

PL. 59
Untitled, 1930s

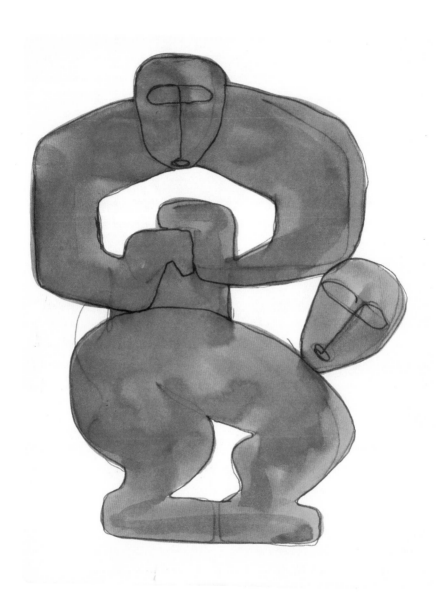

PL. 60
Untitled, 1930s

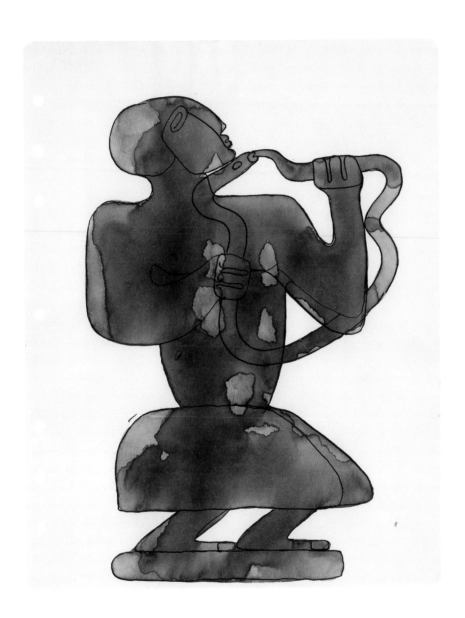

PL. 61
Untitled, 1930s

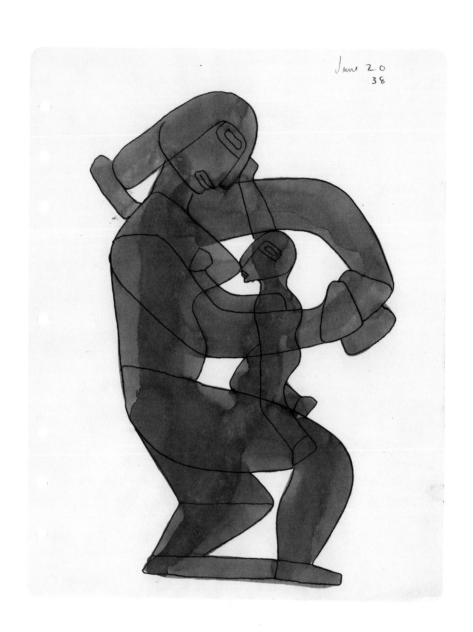

PL. 62
Untitled, 1938

"mystic language
of shapes
of form as shapes
of shape as form"

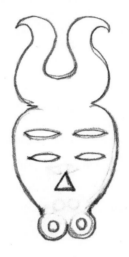

PL. 63
Untitled, 1930s

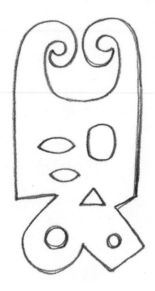

PL. 64
Untitled, 1930s

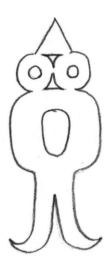

PL. 65
Untitled, 1930s

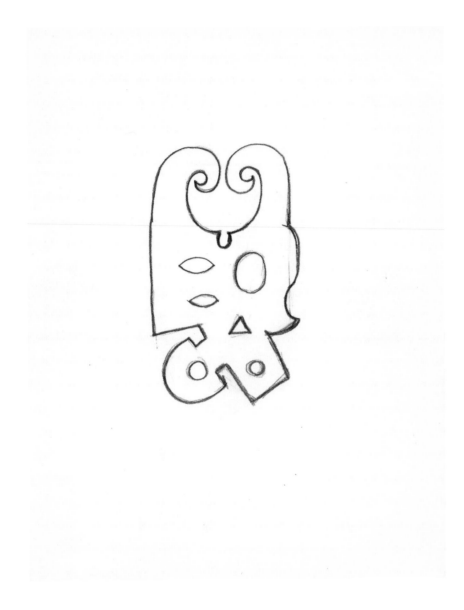

PL. 66
Untitled, 1930s

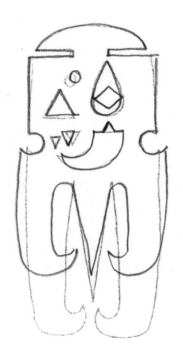

PL. 67
Untitled, 1930s

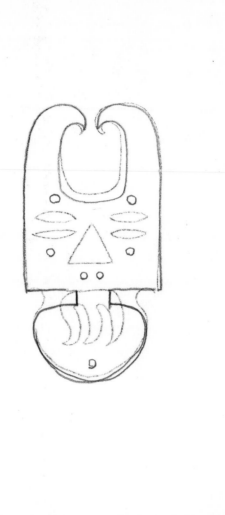

PL. 68
Untitled, 1930s

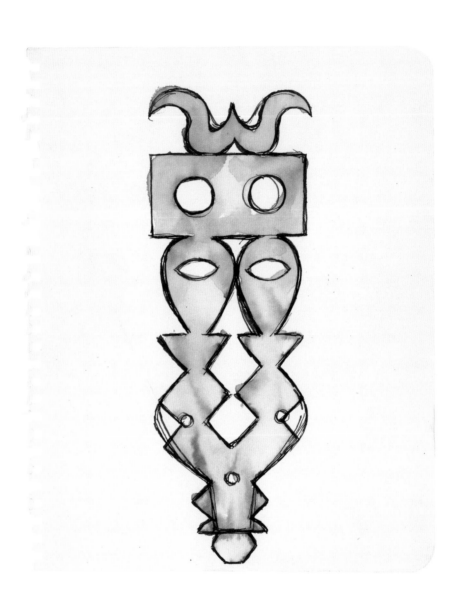

PL. 69
Untitled, 1930s

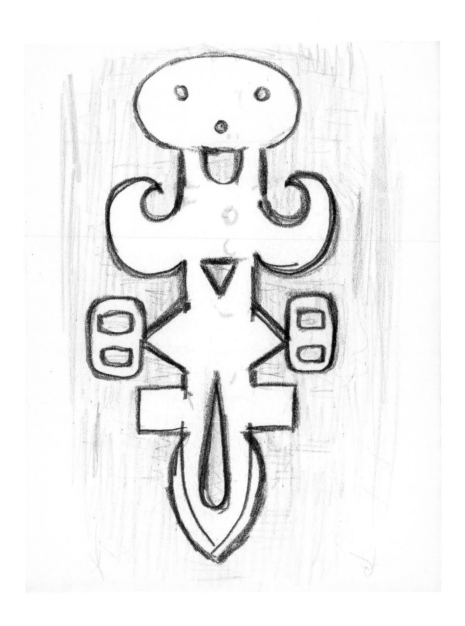

PL. 70
Untitled, 1930s

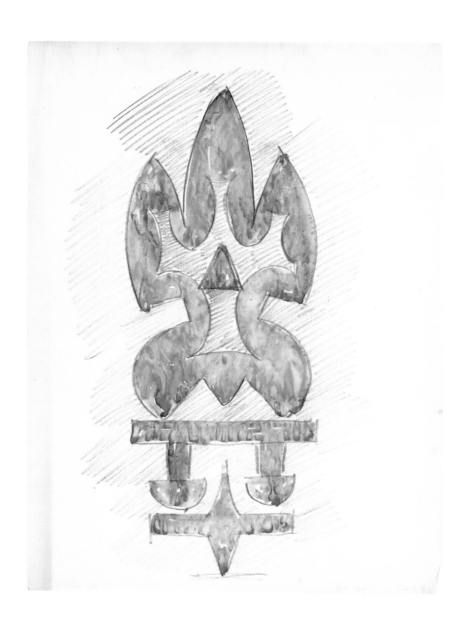

PL. 71
Untitled, 1930s

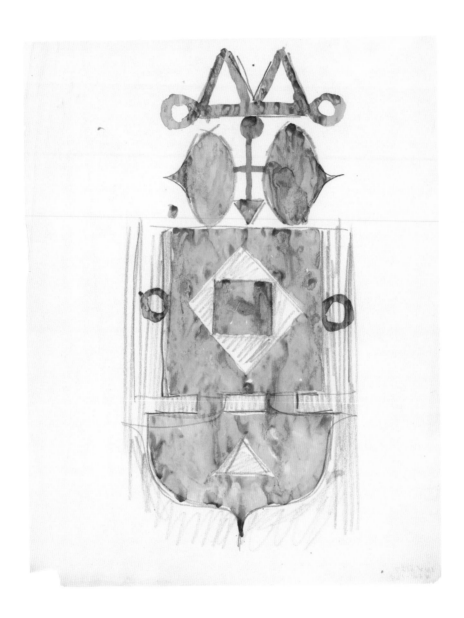

PL. 72
Untitled, 1930s

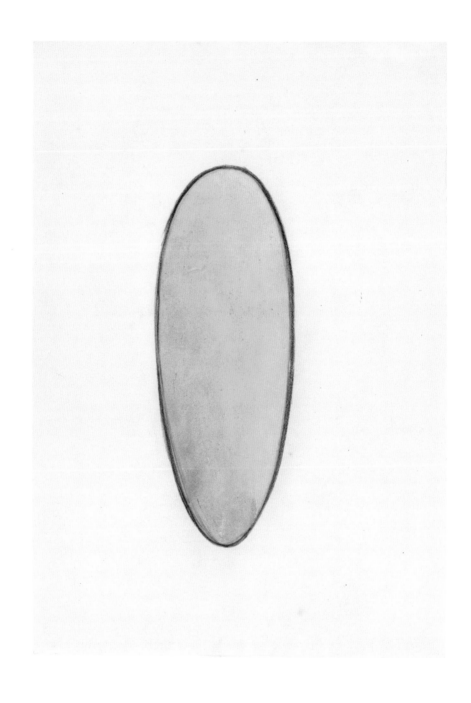

PL. 73
Untitled, 1930s

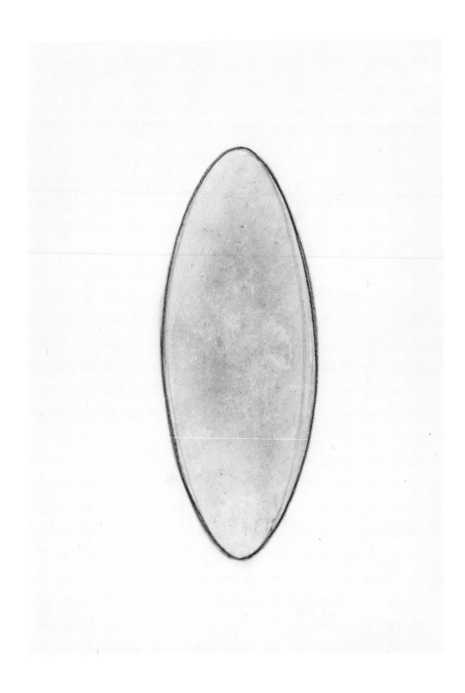

PL. 74
Untitled, 1930s

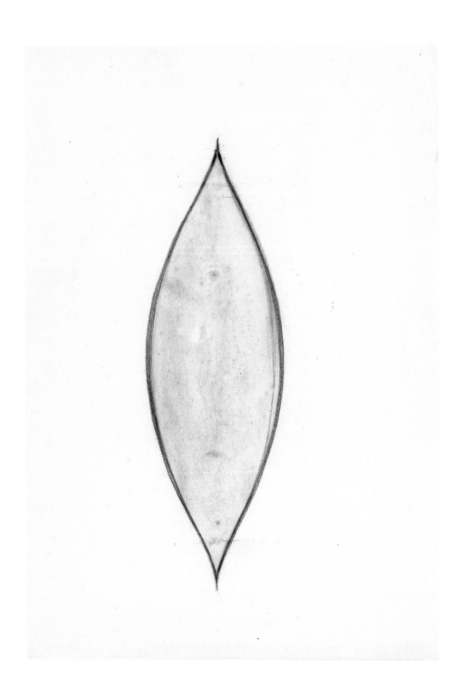

PL. 75
Untitled, 1930s

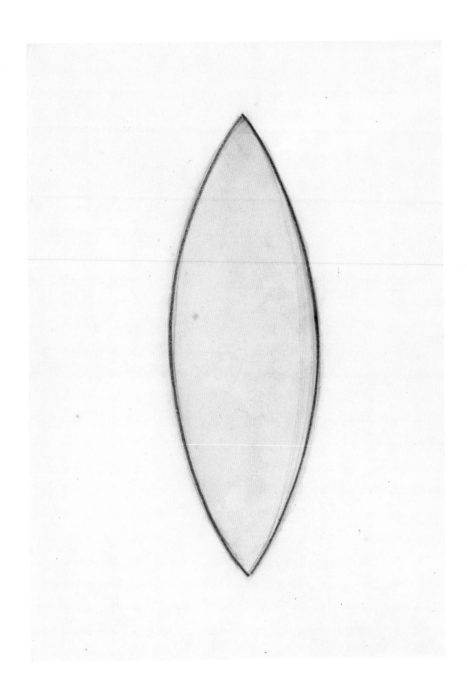

PL. 76
Untitled, 1930s

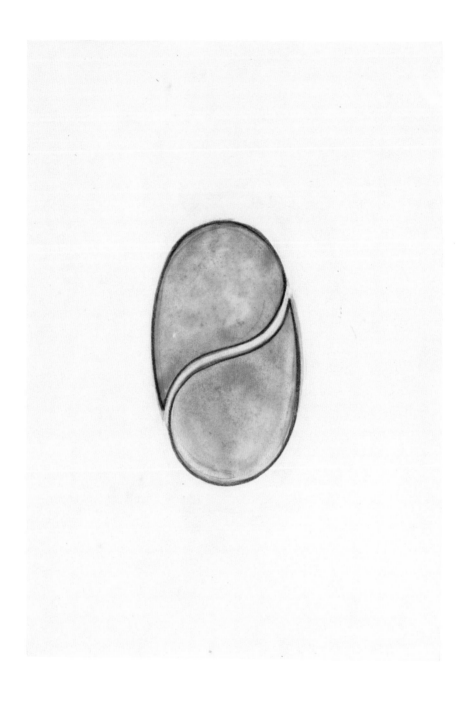

PL. 77
Untitled, 1930s

PL. 78
Untitled, 1930s

*"all methods lead, if sufficiently
pursued, to the significance of form...
the signature of a work of art is the spirit of its form."*

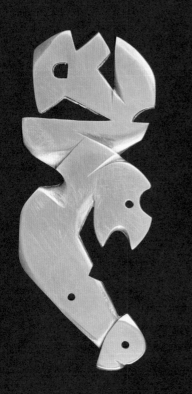
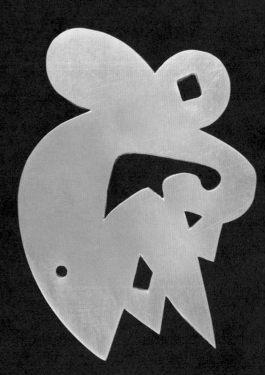

PLS. 79–82
Untitled, 1939 / *Untitled*, 1940 / *Untitled*, 1940 / *Untitled*, 1940

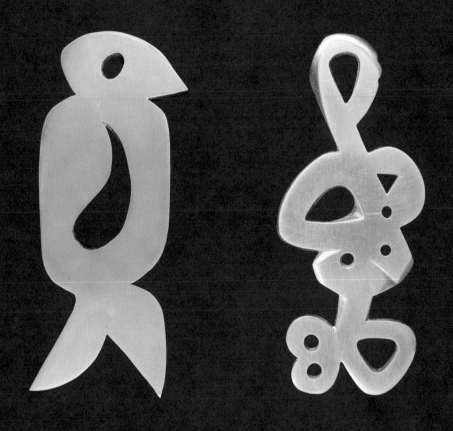

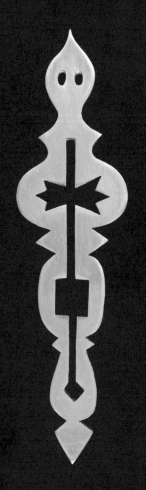
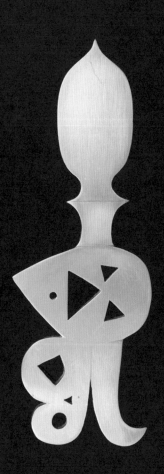

PLS. 83–86
Untitled, 1940 / *Untitled*, 1940 / *Untitled*, 1941 / *Untitled*, 1940

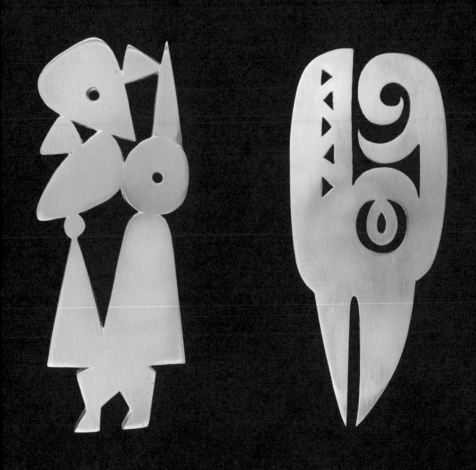

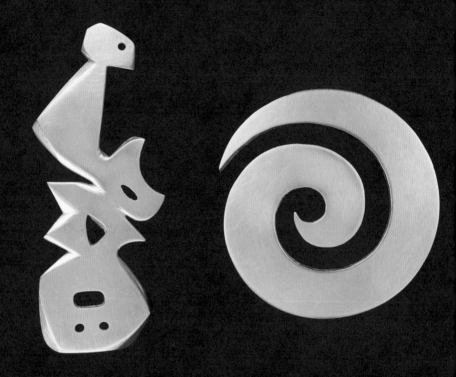

PLS. 87–90
Untitled, 1942 / *Untitled*, 1989 / *Untitled*, 1950 / *Untitled*, 1955

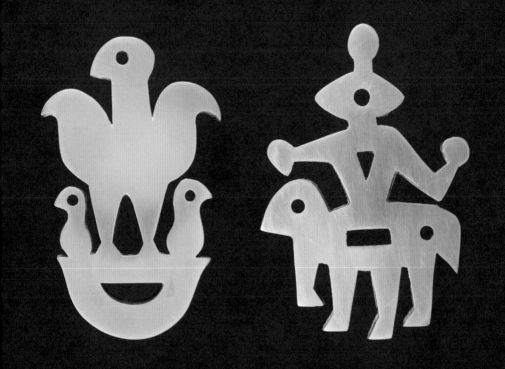

"the pure white page of
paper or canvas can
become anything—in art everything is
transformable."

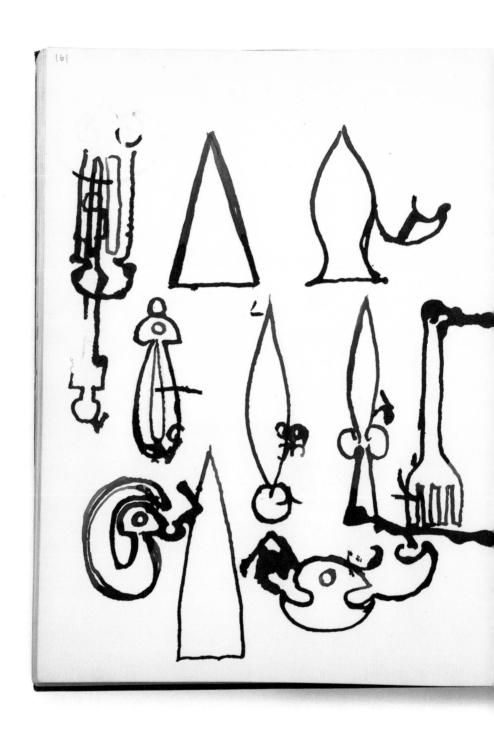

PL. 91
Pages 161–62 from Notebook B-87, 1950s

everything gets accomplished

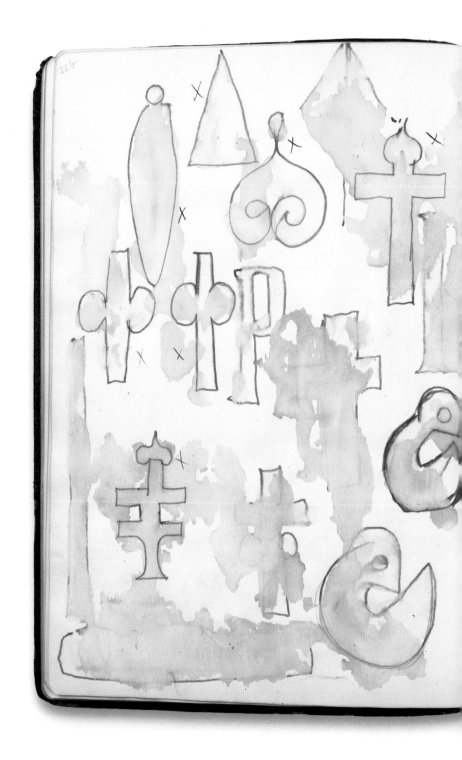

PL. 92
Pages 22–23 from Notebook B-94, 1950s

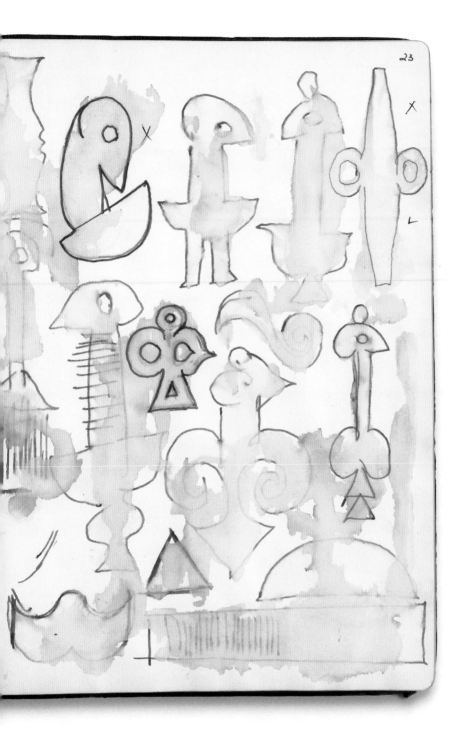

X

X

L

S

PL. 12
Untitled, 1937
Conté on paper
22 1/2 x 18 inches (57.2 x 45.7 cm)
J & J Collection
Inv. no. 5312

PL. 13
Untitled, 1930s
Ink and wash on paper
16 3/4 x 13 1/2 inches (42.5 x 34.3 cm)
Inv. no. 876

PL. 14
Untitled, 1930
Ink and wash on paper
17 x 14 inches (43.2 x 35.6 cm)
Inv. no. 1001.2

PL. 15
Untitled, 1930s
Oil and gouache on paper
16 3/4 x 13 3/4 inches (42.5 x 34.9 cm)
Inv. no. 1032

PL. 16
Untitled (Two Figures), 1930s
Ink on paper
17 x 14 inches (43.2 x 35.6 cm)
Inv. no. 1076

PL. 17
Untitled, 1930s
Ink and wash on paper
18 x 14 1/2 inches (45.7 x 36.8 cm)
J & J Collection
Inv. no. 4240

PL. 18
Untitled, 1930s
Wash on paper
16 3/4 x 13 3/4 inches (42.5 x 34.9 cm)
J & J Collection
Inv. no. 5343

PL. 19
Untitled, 1930s
Wash on paper
16 3/4 x 13 3/4 inches (42.5 x 34.9 cm)
J & J Collection
Inv. no. 5344

PL. 20
Untitled, 1930s
Wash on paper
16 3/4 x 13 1/2 inches (42.5 x 34.3 cm)
J & J Collection
Inv. no. 5465

PL. 21
Untitled, 1930s
Brush, ink, wash
17 x 14 inches (43.2 x 35.6 cm)
J & J Collection
Inv. no. 6002

PL. 22
Untitled, 1930s
Ink, brush and wash on tan paper
17 x 14 inches (43.2 x 35.6 cm)
J & J Collection
Inv. no. 6006

PL. 23
Untitled, 1930s
Ink on paper
12 3/4 x 10 inches (32.4 x 25.4 cm)
J & J Collection
Inv. no. 5565

PL. 24
Untitled, 1930s
Ink on paper
12 3/4 x 9 1/2 inches (32.4 x 24.1 cm)
J & J Collection
Inv. no. 5268

PL. 25
Untitled, 1930s
Ink on paper
16 3/4 x 13 1/2 inches (42.5 x 34.3 cm)
Inv. no. 882

PL. 26
Untitled, 1930
Ink on paper
12 1/2 x 9 inches (31.8 x 22.9 cm)
Inv. no. 957

PL. 27
Untitled, 1930s
Ink on paper
12 3/4 x 10 inches (32.4 x 25.4 cm)
J & J Collection
Inv. no. 5266

PL. 28
Untitled, 1930s
Ink on paper
16 3/4 x 13 3/4 inches (42.5 x 34.9 cm)
Inv. no. 1035

PL. 29
Untitled, 1930s
Ink on paper
16 x 11 3/4 inches (40.6 x 29.8 cm)
Inv. no. 900

PL. 30
Untitled, 1930s
Ink on paper
15 7/8 x 11 7/8 inches (40.3 x 30.2 cm)
Inv. no. 899

PL. 31
Untitled, 1930s
Ink on paper
12 3/4 x 10 inches (32.4 x 25.4 cm)
J & J Collection
Inv. no. 5564

PL. 32
Untitled
1930
Ink on paper
13 3/4 x 16 7/8 inches (34.9 x 42.9 cm)
Inv. no. 2076

PL. 33
Untitled, 1930s
Ink on paper
18 x 14 inches (45.7 x 35.6 cm)
Inv. no. 888

PL. 34
Untitled, 1939
Ink on paper
16 7/8 x 13 3/4 inches (42.9 x 34.9 cm)
Inv. no. 2082

PL. 35
Untitled, 1930s
Ink on paper
10 x 8 inches (25.4 x 20.3 cm)
J & J Collection
Inv. no. 3403

PL. 36
Untitled, 1930s
Ink on paper
10 x 8 inches (25.4 x 20.3 cm)
J & J Collection
Inv. no. 3404

PL. 37
Mythic Head of a Woman, 1930
Ink on paper
16 3/4 x 13 7/8 inches (42.5 x 35.2 cm)
Inv. no. 4087

PL. 38
Untitled, 1930s
Watercolor, ink, graphite, and wash on paper
11 x 8 1/2 inches (27.9 x 21.6 cm)
J & J Collection
3390

PL. 39
Untitled, 1930s
Ink and wash on paper
11 x 8 1/2 inches (27.9 x 21.6 cm)
J & J Collection
Inv. no. 3391

PL. 40
Untitled, 1930s
Watercolor and ink on paper
11 x 8 1/2 inches (27.9 x 21.6 cm)
J & J Collection
Inv. no. 3392

PL. 41
Untitled, 1930s
Pastel and graphite on paper
16 3/4 x 13 3/4 inches (42.5 x 34.9 cm)
Inv. no. 2075

PL. 42
Untitled (L'Enfant Terrible Perceiving Death), 1935
Ink and wash on paper
15 3/4 x 11 3/4 inches (40 x 29.8 cm)
Inv. no. 901

PL. 43
Untitled, 1930s
Graphite on paper
16 3/4 x 14 inches (42.5 x 35.6 cm)
Inv. no. 1043

PL. 44
Two Figures, 1930s
Ink and crayon on paper
17 x 14 inches (43.2 x 35.6 cm)
Inv. no. 1087

PL. 45
Untitled, 1930s
Watercolor, ink, and graphite on paper
11 x 8 1/2 inches (27.9 x 21.6 cm)
J & J Collection
Inv. no. 3266

PL. 46
Untitled (Egor the Monster), 1939
Ink and wash on paper
10 15/16 x 8 7/16 inches (27.8 x 21.4 cm)
Inv. no. 4172

PL. 47
Untitled, 1930s
Graphite on paper
10 x 7 1/2 inches (25.4 x 19 cm)
J & J Collection
Inv. no. 5534

PL. 48
Untitled, 1930s
Ink and wash on paper
8 1/2 x 11 inches (21.6 x 27.9 cm)
Inv. no. 723

PL. 49
Untitled, 1930s
Ink and wash on paper
8 1/2 x 11 inches (21.6 x 27.9 cm)
Inv. no. 746

PL. 50
Untitled, 1930s
Ink and wash on paper
8 1/2 x 11 inches (21.6 x 27.9 cm)
Inv. no. 773

PL. 51
Untitled, 1930s
Ink and wash on paper
8 1/2 x 11 inches (21.6 x 27.9 cm)
Inv. no. 844

PL. 52
Untitled, 1930s
Ink and wash on paper
8 1/2 x 11 inches (21.6 x 27.9 cm)
Inv. no. 904

PL. 53
Untitled, 1930s
Ink and wash on paper
11 x 8 1/2 inches (27.9 x 21.6 cm)
Inv. no. 776

PL. 54
Untitled, 1930s
Ink and wash on paper
11 x 8 1/2 inches (27.9 x 21.6 cm)
Inv. no. 764

PL. 55
Untitled, 1930s
Ink and wash on paper
11 x 8 1/2 inches (27.9 x 21.6 cm)
J & J Collection
Inv. no. 4765

PL. 56
Untitled, 1930s
Watercolor and ink on paper
11 x 8 1/2 inches (27.9 x 21.6 cm)
Inv. no. 912

PL. 57
Untitled
1930s
Ink and wash on paper
11 x 8 1/2 inches (27.9 x 21.6 cm)
Inv. no. 845

PL. 58
Untitled, 1930s
Ink and wash on paper
11 x 8 1/2 inches (27.9 x 21.6 cm)
J & J Collection
Inv. no. 4909

PL. 59
Untitled, 1930s
Ink and wash on paper
11 x 8 1/2 inches (27.9 x 21.6 cm)
J & J Collection
Inv. no. 5028

PL. 60
Untitled, 1930s
Ink and wash on paper
11 x 8 1/2 inches (27.9 x 21.6 cm)
J & J Collection
Inv. no. 5070

PL. 61
Untitled, 1930s
Ink and wash on paper
11 x 8 1/2 inches (27.9 x 21.6 cm)
J & J Collection
Inv. no. 4897

PL. 62
Untitled, 1938
Ink and wash on paper
11 x 8 1/2 inches (27.9 x 21.6 cm)
J & J Collection
Inv. no. 5003

PL. 63
Untitled, 1930s
Graphite on paper
11 x 8 1/2 inches (27.9 x 21.6 cm)
J & J Collection
Inv. no. 5542

PL. 64
Untitled, 1930s
Graphite on paper
11 x 8 1/2 inches (27.9 x 21.6 cm)
J & J Collection
Inv. no. 5544

PL. 65
Untitled, 1930s
Graphite on paper
11 x 8 1/2 inches (27.9 x 21.6 cm)
J & J Collection
Inv. no. 5549

PL. 66
Untitled, 1930s
Graphite on paper
11 x 8 1/2 inches (27.9 x 21.6 cm)
J & J Collection
Inv. no. 5545

PL. 67
Untitled, 1930s
Graphite on paper
11 x 8 1/2 inches (27.9 x 21.6 cm)
J & J Collection
Inv. no. 5546

PL. 68
Untitled, 1930s
Graphite on paper
11 x 8 1/2 inches (27.9 x 21.6 cm)
J & J Collection
Inv. no. 5541

PL. 69
Untitled, 1930s
Pencil and wash
10 x 7 3/4 inches (25.4 x 19.7 cm)
J & J Collection
Inv. no. 6130

PL. 70
Untitled, 1930s
Pencil and Crayon
11 x 8 1/2 inches (27.9 x 21.6 cm)
J & J Collection
Inv. no. 6129

PL. 71
Untitled, 1930s
Graphite and wash on paper
11 x 8 1/2 inches (27.9 x 21.6 cm)
Inv. no. 931

PL. 72
Untitled, 1930s
Pencil and Wash
11 x 8 1/2 inches (27.9 x 21.6 cm)
J & J Collection
Inv. no. 6127

PL. 73
Untitled, 1930s
Pencil and wash
10 1/2 x 7 1/4 inches (26.7 x 18.4 cm)
The Richard Pousette-Dart Foundation
Inv. no. 6124

PL. 74
Untitled, 1930s
Pencil and wash
10 1/2 x 7 1/4 inches (26.7 x 18.4 cm)
The Richard Pousette-Dart Foundation
Inv. no. 6133

PL. 75
Untitled
1930s
Pencil and wash
10 1/2 x 7 1/4 inches (26.7 x 18.4 cm)
The Richard Pousette-Dart Foundation
Inv. no. 6126

PL. 76
Untitled, 1930s
Pencil and wash
10 1/2 x 7 1/4 inches (26.7 x 18.4 cm)
The Richard Pousette-Dart Foundation
Inv. no. 6132

PL. 77
Untitled, 1930s
Pencil and wash
10 1/2 x 7 1/4 inches (26.7 x 18.4 cm)
The Richard Pousette-Dart Foundation
Inv. no. 6125

PL. 78
Untitled, 1930s
Pencil and wash
10 1/2 x 7 1/4 inches (26.7 x 18.4 cm)
The Richard Pousette-Dart Foundation
Inv. no. 6134

PL. 79
Untitled, 1939
Hand-carved brass
4 7/8 inches (12.4 cm) high
Inv. no. 1669

PL. 80
Untitled, 1940
Hand-carved brass
3 1/2 inches (8.9 cm) wide
Inv. no. 1677

PL. 81
Untitled, 1940
Hand-carved brass
5 x 2 x 1/4 inches (12.7 x 5.1 x 0.6 cm)
Inv. no. 1681

PL. 82
Untitled, 1940
Hand-carved brass
4 1/8 inches (10.5 cm) high
Inv. no. 1682

PL. 83
Untitled, 1940
Hand-carved brass
7 x 1 7/8 x 1/4 inches (17.8 x 4.8 x 0.6 cm)
Inv. no. 1683

PL. 84
Untitled, 1940
Hand-carved brass
6 3/8 inches (16.2 cm) high
Inv. no. 1684

PL. 85
Untitled, 1941
Hand-carved brass
5 1/2 x 2 1/4 x 1/4 inches (14 x 5.7 x 0.6 cm)
Inv. no. 1690

PL. 86
Untitled, 1940–50
Hand-carved brass
2 1/2 x 6 x 1/8 inches (6.4 x 15.2 cm)
J & J Collection
Inv. no. 1695

PL. 87
Untitled, 1942
Hand-carved brass
4 3/4 inches (12.1 cm) high
Inv. no. 1697

PL. 88
Untitled, 1989
Hand-carved brass
3 1/16 x 3 x 1/4 inches (7.8 x 7.6 x 0.6 cm)
Inv. no. 1740

PL. 89
Untitled, 1950
Hand-carved brass
3 x 1 7/8 x 1/4 inches (7.6 x 4.8 x 0.6 cm)
Inv. no. 1722

PL. 90
Untitled, 1955
Hand-carved brass
3 1/4 inches (8.3 cm) high
Inv. no. 1728

PL. 91
Pages 161–62 from Notebook B-87, 1950s
Ink and pencil
22 x 8 1/2 inches

PL. 92
Pages 22–23 from Notebook B-94, 1950s
Ink and watercolor
19 x 7 inches

EXHIBITION WORKS NOT PICTURED

Untitled, 1930s
Pencil
11 x 8 1/2 inches
J & J Collection
Inv. no. 6128

Untitled, 1930s
Pencil
11 x 8 1/2 inches (27.9 x 21.6 cm)
J & J Collection
Inv. no. 6131

Untitled, 1938
Hand-carved brass
H. 4 inches (10.2 cm)
Inv. no. 1666

Untitled, 1938
Hand-carved brass
5 3/16 inches (13.2 cm) high
Inv. no. 1667

Untitled, 1939
Hand-carved brass
6 x 1 7/8 x 1/4 inches (15.2 x 4.8 x 0.6 cm)
Inv. no. 1671

Untitled, 1939
Hand-carved brass
7 5/8 inches (19.4 cm) high
Inv. no. 1672

Untitled, 1939
Hand-carved brass
4 inches (10.2 cm) high
Inv. no. 1673

Untitled, 1940
Hand-carved brass
3 1/4 inches (8.3 cm) high
Inv. no. 1679

Untitled, 1940
Hand-carved brass
5 9/16 inches (14.1 cm) high
Inv. no. 1687

Untitled, 1941
Hand-carved brass
1 5/8 x 3 x 1/8 inches (4.1 x 7.6 x 0.3 cm)
Inv. no. 1691

Untitled, 1942
Hand-carved brass
5 1/4 inches (13.3 cm) high
Inv. no. 1699

Untitled, 1942
Hand-carved brass
4 1/2 inches (11.4 cm) high
Inv. no. 1701

Untitled, 1943
Hand-carved brass
4 1/2 inches (11.4 cm) high
Inv. no. 1705

Untitled, 1947
Hand-carved brass
4 1/2 inches (11.4 cm) high
Estate of the artist
Inv. no. 1713

Untitled, 1948
Hand-carved brass
4 1/8 inches (10.5 cm) high
Inv. no. 1714

Untitled, 1960
Hand-carved brass
4 1/2 x 2 1/8 inches (11.4 x 5.4 cm)
Inv. no. 1731

Untitled, 1960
Hand-carved brass
5 1/4 inches (13.3 cm) high
Inv. no. 1732

Untitled, 1963
Hand-carved brass
3 1/2 x 1 3/4 x 1/4 inches (8.9 x 4.4 x 0.6 cm)
Inv. no. 1733

Untitled
1972
Hand-carved brass
4 1/8 inches (10.5 cm) high
Inv. no. 1734

Untitled, 1986
Hand-carved brass
4 3/4 inches (12.1 cm) high
Inv. no. 1738

Untitled, 1988
Hand-carved brass
2 3/4 inches (7 cm) high
Inv. no. 1739

Untitled, 1950
Hand-carved brass
2 x 2 inches (5.1 x 5.1 cm)
J & J Collection
Inv. no. 5796

Charles H. Duncan is Executive Director of The Richard Pousette-Dart Foundation. He is author of *Absence/Presence: Richard Pousette-Dart as Photographer.*

Lowery Stokes Sims retired as Curator Emerita from the Museum of Arts and Design in New York in 2015. Sims was formerly executive director, president, and adjunct curator at The Studio Museum in Harlem (2000–07). She began her career as an educator and curator at The Metropolitan Museum of Art (1972–99) where she organized a survey of Pousette-Dart's work in 1997.

ACKNOWLEDGMENTS

*Richard Pousette-Dart: 1930*s is
made possible by the support of
The Estate of Richard Pousette-Dart
and Pace Gallery.

EDWARD HALLAM TUCK PUBLICATION PROGRAM

This is number 122 of the *Drawing Papers*, a series of publications documenting
The Drawing Center's exhibitions and public programs and providing a forum for
the study of drawing.

Margaret Sundell *Executive Editor*
Joanna Ahlberg *Managing Editor*
Designed by AHL&CO / Peter J. Ahlberg, Kyle Chaille

This book is set in Adobe Garamond Pro and Berthold Akzidenz Grotesk.
It was printed by Shapco Printing in Minneapolis, MN.

THE
DRAWING
CENTER

35 WOOSTER STREET | NEW YORK, NY 10013
T 212 219 2166 | F 888.380.3362 | DRAWINGCENTER.ORG